GOLF
IN
SCOTTSDALE

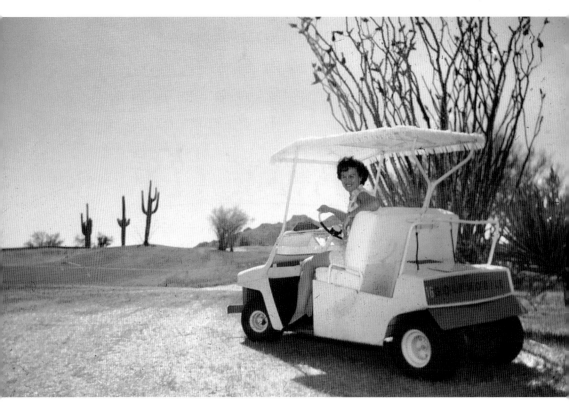

Sundown Ranch Golf Course morphed into Scottsdale Country Club and is now known as Starfire at Scottsdale Country Club. It opened in 1953 and is Scottsdale's oldest continuously operated public golf course. This view is from around 1966. (Scottsdale Historical Society.)

FRONT COVER: The Ingleside Inn Golf Course was the first course in Scottsdale and opened shortly after W. J. and Ralph Murphy opened the inn around 1910. The Ingleside Golf Course operated through World War II; after the inn became the Brownmoor School for Girls, the course was acquired and modernized by the Arizona Country Club. (Dorothy Robinson Collection, Arizona Collection, Arizona State University Libraries.)

COVER BACKGROUND: In 1932, the Phoenix Open, which is now known as the FBR Open, played its first tournament at the Phoenix Country Club. Throughout the 1950s and 1960s, the annual PGA tournament alternated between the Phoenix and Arizona Country Clubs. In 1987, the hosting Thunderbirds moved their tournament to the new TPC Scottsdale Stadium Course. Here Tom Watson prepares to hit before a crowd of spectators in one of the first events held at TPC Scottsdale. (*Scottsdale Airpark News.*)

BACK COVER: "The Gunsight," the par-four 16th hole at Troon Country Club, is one of many scenic holes created by PGA champion and Scottsdale-based course designer Tom Weiskopf and golf course designer Jay Morrish. Troon Country Club, opened in 1986, was named for Royal Troon Golf Club in Troon, South Ayshire, Scotland, where Weiskopf won the British Open in 1973. (Author's collection.)

GOLF
IN
SCOTTSDALE

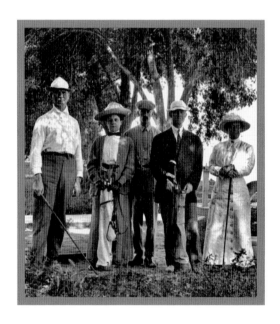

Joan Fudala

ARCADIA
PUBLISHING

Published by Arcadia Publishing
Charleston SC, Chicago IL, Portsmouth NH, San Francisco CA

Printed in the United States of America

Library of Congress Catalog Card Number: 2007941883

For all general information contact Arcadia Publishing at:
Telephone 843-853-2070
Fax 843-853-0044
E-mail sales@arcadiapublishing.com
For customer service and orders:
Toll-Free 1-888-313-2665

Visit us on the Internet at www.arcadiapublishing.com

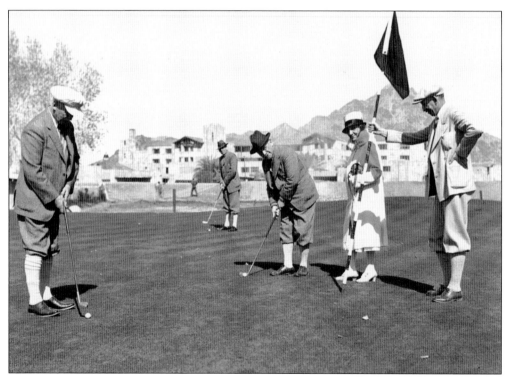

Although some Scottsdale-area golf courses have a moderate dress code today, none would require the formality of these 1930s-era golfers at the Arizona Biltmore course. (Arizona Historical Foundation.)

CONTENTS

ACKNOWLEDGMENTS

As a community historian, I thought I knew a lot about Scottsdale. Researching a book about the history of golf in Scottsdale, however, took me to people and places I had never been. What I found were mostly bits and pieces of what surely has been a fascinating process, evolving from the era of dirt fairways and oiled sand greens to the present array of golf courses known throughout the world and played by the world's best-known golfers. Historic facts were exceptionally hard to nail down; please excuse any errors of omission or commission. Photographs of many past courses, golf stars, and events were nonexistent, copyrighted, or not located; space was too limited to include photographs of every course, golfer, business, or event; those included are representative of all that Scottsdale has had to offer over its century of golf.

My intent was to collect scattered and previously unpublished facts and photographs to put into the hands of those who love the history and tradition of golf and everything that surrounds it. I also hope the photographs in this book will bring back many pleasant memories of games, friends, and beautifully challenging courses.

I have been playing golf for nearly 50 years, and I thank my mom and dad for introducing me to the fun and camaraderie of the game they enjoyed so much. I also thank my husband, Gene, who has suffered through the ups and downs of my very uncompetitive game for over 30 years. We have had some of our best times on golf courses throughout the United States and with dear friends in England, Germany, France, and even while stationed in South Korea.

Many thanks to the research assistance from the Arizona Historical Foundation, Arizona State University (ASU) Archives/Rob Spindler, Scottsdale Historical Society/Joann Handley, the Thunderbirds/Cheryl Ruggiero, Communication Links/Ryan Woodcock, Phil Schneider at The Lyle Anderson Company, Carey Fassler at Desert Highlands, former publisher of the *Arizonian* Dr. Mae Sue Talley, and the many golf courses, golf companies, and private individuals who loaned the use of their photographs to make this book possible.

If you have photographs of golf in Scottsdale, I urge you to donate them to the Scottsdale Historical Society, the Scottsdale Public Library's historic photograph collection, the Arizona State University archives, the Arizona Historical Foundation, or other archives who will share them with historians, students, and other interested parties.

INTRODUCTION

It surely must have been destiny. The same year golf arrived from Scotland to the United States—1888—was coincidentally the same year in which Chaplain Winfield Scott homesteaded desert land that later evolved into the golf mecca of Scottsdale. Yonkers, New York, was the site of the first American golf course, established in 1888. Within 12 years, the sport had migrated as far west as the Arizona Territory. The Salt River Valley opened its first golf course—the Phoenix Golf Club, forerunner of Phoenix Country Club—at the dawn of the 20th century on land near the present site of the state capitol.

The Arizona Territory had all the land a golf course could ever need. The Salt River Valley of Central Arizona boasted well over 300 days of sunshine annually and warm, dry winters, other assets that could attract golfers and golf course developers. Water, however, was a scarce commodity and mainly directed via a network of canals toward the citrus and cash crop agricultural industry that drove the local economy.

Ten years after the founding of Phoenix Country Club, golf came to the outskirts of the small farming community east of Phoenix called Scottsdale. The Scottsdale area's first winter luxury resort, the Ingleside Inn, included a nine-hole golf course. Hoping to attract rich investors from the Midwest to his land in the newly irrigated Salt River Valley, canal guru W. J. Murphy opened a posh private club in 1910 in what is now known as the Arcadia District. He called it the Ingleside Club, with the motto "Where Summer Loves to Linger and Winter Never Comes." Murphy and his son Ralph put in a golf course to accommodate guests from Midwest cities that had already enthusiastically embraced the game of golf.

Just imagine a foursome's weekly game in c. 1910 Scottsdale: they head out to the course dressed in jackets, ties, and knickers and driving caps; they hit their drives down a dirt fairway; then, after sweeping a path to the hole with a special broom-line device, putt into the hole on an oiled sand "green." Perhaps because golf was new, or too rugged, the preferred lawn or mallet games were croquet and polo. It wasn't until the 1920s that Arizona golf courses introduced grass to their fairways and greens.

When the San Marcos Inn in Chandler, the Arizona Biltmore Hotel in Phoenix, and the Wigwam Resort in Litchfield Park opened in the late 1910s and 1920s, the Salt River Valley began marketing golf as one of several climate-oriented tourist attractions. There were enough golf enthusiasts and tournaments by 1923 that an organizing body was needed; the Arizona Golf Association was established that year. The sport received a further boost when the Phoenix Open tournament began in 1932 and Phoenix opened a municipal course at its new Encanto Park in 1935. At the start of World War II, however, there were still only 19 courses in the entire state according to listings in the 1941–1942 Arizona Business and Professional Directory.

Like so many other industries, golf had a mini-boom after World War II. The Salt River Valley—now calling itself the Valley of the Sun—eagerly promoted itself to Midwesterners and

Easterners as the ideal winter destination. More golf courses sprang up to meet the demands of new, well-heeled residents and sophisticated visitors. Most golf courses followed traditional "back East" design, turning desert land into lush, grass-covered fairways lined with trees, shrubs, and flowers. Incorporating the desert into the design and challenge of a course began in 1962 with the opening of Desert Forest Golf Club in Carefree, just north of Scottsdale, and fully took off when Jack Nicklaus designed Desert Highlands Golf Course in northern Scottsdale in 1983.

Scottsdale's golf history goes far beyond its array of courses and annual tournaments. Besides the desert golf concept, several other significant golf innovations have a Scottsdale connection. In the 1960s, Karsten Solheim put the Scottsdale name on one of his most prized PING putters; it has become a super-collectible. During the 1980s, Scottsdale became a municipal leader by encouraging use of reclaimed water on golf courses to foster water conservation.

In 1990, Dana Garmany launched Troon Golf, now a world leader in upscale golf course management. Also in the 1990s, Roger Maxwell opened the first of his popular In Celebration of Golf shop–museum–art gallery–club fitting stores, now a national franchise and a statewide golf management company.

The list of celebrities and golf professionals who have graced Scottsdale's links is endless. Most of golf's renowned course designers have cut their teeth or made their mark here. Golf instruction and golf schools bring duffer and pro alike to Scottsdale golf courses. Despite all the fame and glory generated by Scottsdale's international golf reputation, it is the personal golf histories, created every day, that live in golfers' hearts and bring them back game after game. Maybe it's their first par, birdie, or hole-in-one; or finally breaking 100; or beating their dad or college roommate; or teaching their child to play golf—these are the most important milestones of the history of golf in Scottsdale.

Conceived at a meeting in the fall of 1899, the Phoenix Golf Club was established at the turn of the 20th century and held its first tournament February 22, 1900. Just nine holes of dirt fairways and oiled sand greens, the club moved three times in its first years, finally landing at Thomas Road and Seventh Street, where it is today. This humble but cozy clubhouse served those who played the game when it was dusty, hot, and pure sport. (Arizona Historical Foundation.)

1

Adapting the Desert
for Golf

1899-1960

Reflecting national travel and sporting trends and economic conditions during the first half of the 20th century, golf grew slowly but steadily in the Scottsdale area. For residents and tourists coming to the Scottsdale area between 1910 and 1940, golf took its place among other outdoor sports and leisure activities of the era.

From 1910, when W. J. Murphy and his son Ralph opened the Ingleside Club's nine-hole golf course, to the end of World War II in 1945, Ingleside remained Scottsdale's one and only golf course. Elsewhere in the Valley of the Sun, a few other golf courses were established, such as the Phoenix Country Club (1899), San Marcos Hotel Golf Course (1913), Arizona Biltmore (1929), the Wigwam Golf Course (1930), and Encanto Golf Course (1935). In the 1920s, local chambers of commerce began promoting golf as a good reason to spend the winter in the balmy desert. The Phoenix Open began in 1932 and was adopted as a major project of the newly formed men's civic group, the Phoenix Thunderbirds, in the late 1930s. Today it is known as the FBR Open and is one of Scottsdale's signature events and economic engines.

After World War II, the demand for private golf country clubs, golf courses associated with hotels and resorts, and public/daily-fee golf spurred steady development of courses and ranges in and around Scottsdale. A postwar tourism boom turned the prewar farming town of Scottsdale into a retail arts, crafts, sports, and recreation destination. Farming was the chief occupation in Scottsdale from 1888 to the 1940s; after the war, farms were sold and a new affluent population, not burdened by round-the-clock farm chores, created demand for leisure activities like golf.

Although desert cacti and rock formations may have been considered quaint, little was done to preserve the natural desert environment in the 1940s and 1950s golf course design. Golf courses, like housing and commercial developments, were bulldozed, irrigated, and planted with nonindigenous flowers and plants. That attitude would change dramatically in the 1980s and beyond.

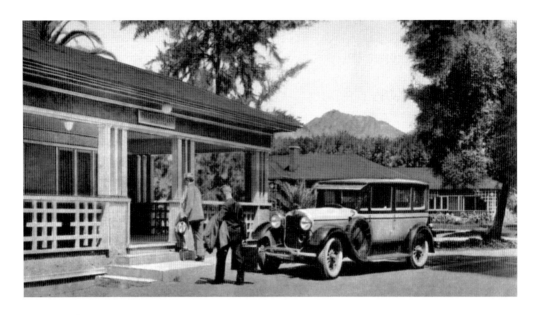

Arizona Canal builder and land developer W. J. Murphy and his son Ralph opened the Ingleside Club around 1910 and with it the Scottsdale area's first golf course. Murphy planted citrus groves on land near the Arizona Canal around the 1890s and envisioned a community he called Ingleside. Murphy opened the Ingleside Club as a private inn where he could entertain potential land investors from "back East." Advertising brochures described to travelers, "Phoenix may be reached by either the Santa Fe or Southern Pacific railways. Once in Phoenix, visitors should report to the Phoenix Trust Company office, where conveyances, either by automobiles [photograph above], stage, or private conveyance, can be arranged. The trip from Phoenix consumes half an hour by automobile or one and one-half hours by stage [photograph below]." (Above, *Ingleside and its Inn, 1929*, Arizona Collection, Arizona State University Libraries; below, Scottsdale Historical Society.)

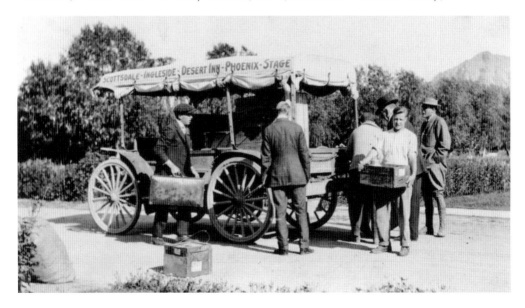

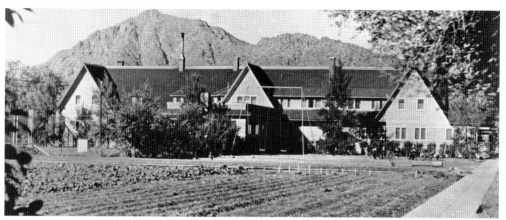

The Ingleside Club, located 9 miles from Phoenix on unpaved Indian School Road approaching the small farm town of Scottsdale, was comprised of a two-story main building and adjacent bungalows. Brochures promised guests that the club was "designed to give home comforts to those disinclined to undertake housekeeping; it also offers relief from the annoyance of hotel life. . . . The cuisine of the club is strictly first-class. The table is set with the best that the market affords. The club maintains its own vegetable garden, chicken yard and dairy." Ingleside, open November to May, was known for its olive-fed turkeys. (Scottsdale Public Library.)

Ingleside offered adventurous golfers raw desert fairways and oiled sand greens. The course may have lacked certain amenities, but it offered breathtaking scenery. The original nine holes were north of the Arizona Canal, reached from the Ingleside Club over a footbridge. The course was situated in the shadow of nearby Camelback Mountain to the north and within sight of the Papago Buttes to the south. (Arizona Historical Foundation.)

Golf at Ingleside and other Valley courses was popular with both men and women. In fact, golf was one of the few sports of the day women could enjoy with men, although their golf attire was rather restrictive. One of the state's best amateur female golfers in the early 1900s was Josephine Goldwater, wife of merchant Morris Goldwater and mother to Carolyn, Barry, and Bob. (Arizona Historical Foundation.)

The June 1914 edition of *Arizona—The State Magazine* stated, "The golf links at Ingleside are said by authoritative players to be worthy [sic] this most ambitious of games, having in the course the Arizona canal as a water hazard that has worked the undoing of many noted players. The greater part of the golf grounds are laid out on the north side of the canal opposite the club buildings, most of this land had considerable elevation above the surrounding country, thus being impossible to irrigate with present facilities." (Dorothy Robinson Collection, Arizona Collection, Arizona State University Libraries.)

An Ingleside Club brochure boasted, "No pains have been spared to make it complete in every detail. The links are under the direct care of Mr. Harry Collis, one of the leading professional golfers of America. Adjoining the golf course are the tennis courts, and nearer the Club House are croquet grounds." Will Robinson helped develop the Ingleside Inn and course; he and Collis also helped design and manage the San Marcos Hotel Golf Course. Mrs. Will (Dorothy) Robinson managed the Ingleside Inn in its early days. (Dorothy Robinson Collection, Arizona Collection, Arizona State University Libraries.)

Grass fairways and greens finally came to Scottsdale and Phoenix golf courses during the 1920s. Ingleside's proximity to the Arizona Canal gave it ready access to water for its turf; however, course irrigation systems were in their infancy. (*Ingleside and its Inn, 1929*, Arizona Collection, Arizona State University Libraries.)

W. J. Murphy's son Ralph took over the Ingleside Club and turned it into Scottsdale's first luxury resort open to the public. He also moved the golf course to the south side of the Arizona Canal in the 1920s and added grass fairways and greens and another nine holes. He continued to operate the inn and golf course into the 1930s, when the Great Depression impacted travel, financing, and golf in general. Other owners kept the course operating into the 1940s, when a nation at war further impacted golf. (Scottsdale Historical Society.)

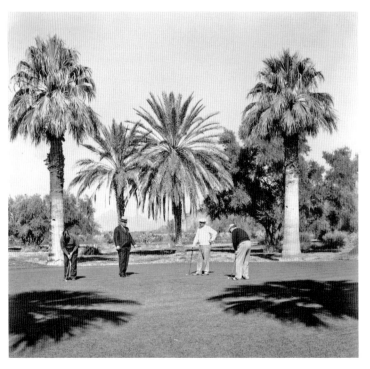

Scottsdale youth, like George "Doc" Cavalliere, earned pocket money by caddying at the Ingleside Golf Course during the 1920s and 1930s. He remembered that his "customers" were mostly local businessmen and that their clubs were heavy to carry. (Dorothy Robinson Collection, Arizona Collection, Arizona State University Libraries.)

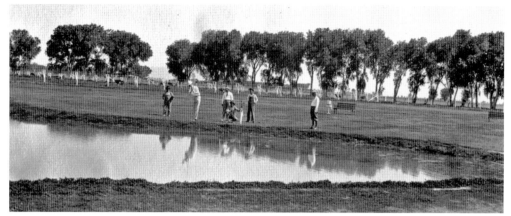

Chandler, a then-new community east of Scottsdale and Phoenix founded by Dr. A. J. Chandler, officially opened its first tourist hotel, the San Marcos, in 1912–1913. The November 1913 edition of *Arizona—The State Magazine* described the new hotel, "In point of entertainment there are golf links, tennis, motoring, horseback riding and all outdoor sports." (Dorothy Robinson Collection, Arizona Collection, Arizona State University Libraries.)

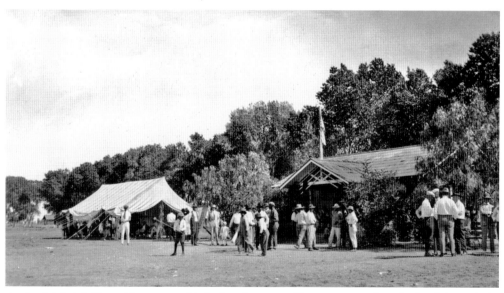

As the third club-like golf course established in the greater Phoenix area, when the San Marcos links opened around 1913, it afforded local golfers another venue for tournaments like the Southwestern Golf Tournament shown in this mid-1910s photograph. (Dorothy Robinson Collection, Arizona Collection, Arizona State University Libraries.)

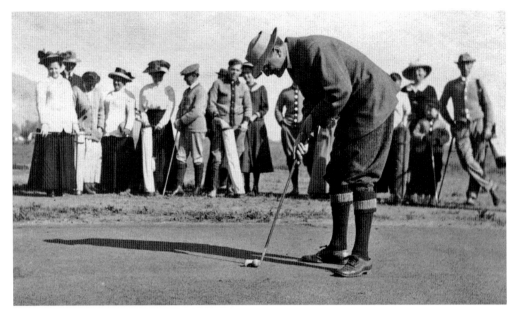

John Witherspoon demonstrates the gentlemen's golf attire of the day—jaunty brimmed hat, sports jacket, knickers, and knee-length socks. Some male golfers also wore spats over their ankles. The gallery was quite formal back in the day as well. (Dorothy Robinson Collection, Arizona Collection, Arizona State University Libraries.)

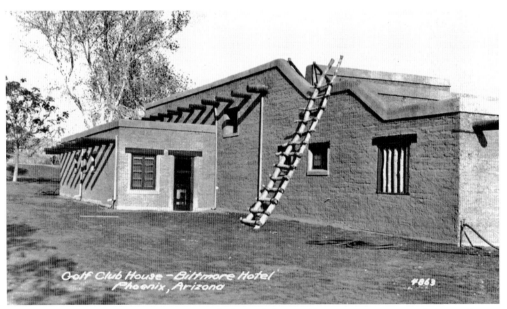

In 1929, the Arizona Biltmore opened the Adobe Golf Course, a rustic adobe and viga Southwestern-designed clubhouse. William P. "Billy" Bell designed the golf course. (Arizona Historical Foundation.)

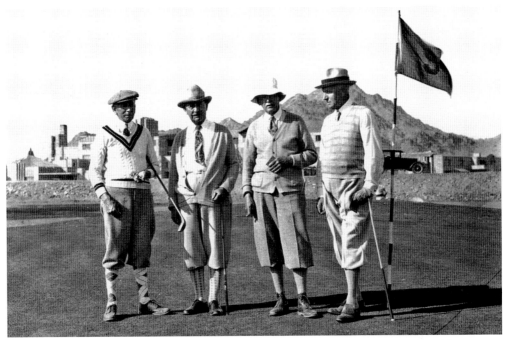

The Arizona Biltmore attracted the rich and famous. Among the Biltmore's golfing guests were actor Clark Gable, ambassador Clare Booth Luce, publisher Henry Luce, and the Duke of Windsor, formerly King Edward VIII of England. This foursome is unidentified. (Arizona Historical Foundation.)

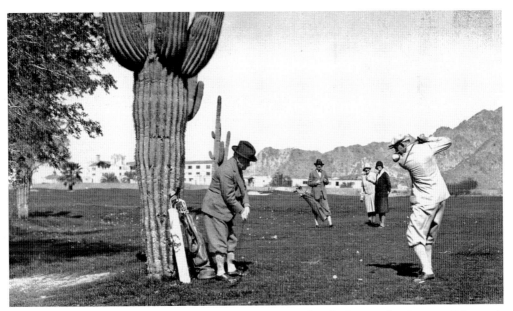

Located north of Camelback Road and east of Twenty-fourth Street, the Arizona Biltmore's Adobe Golf Course was among the first in the Valley of the Sun to have grass fairways and greens. (Arizona Historical Foundation.)

The Arizona Biltmore and its golf course opened in the same year as the stock market crash of 1929. Its original builders/owners, the McArthur brothers—Albert, Warren, and Charles—sold the resort to the Wrigley family in the 1930s, who continued to attract a rich clientele despite the Depression. The original golf pro was Syd Cooper. Cooper was succeeded by renowned teaching professional Bob Hunsick Jr., who remained in the job through 1958. Above, the resort is in the background; the Squaw Peak (renamed Piestewa Peak) is in the background below. (Both Arizona Historical Foundation.)

ADAPTING THE DESERT FOR GOLF: 1899–1960

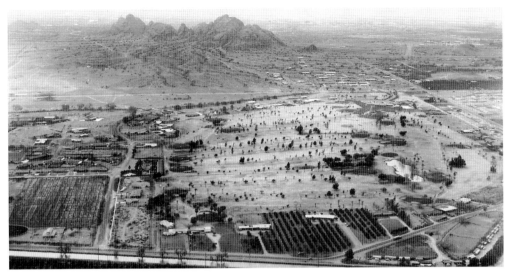

Chartered in 1946, the Arizona Country Club (ACC) converted many of the holes of the former Ingleside Inn Golf Course into its layout. The team of Ernest Suggs and Willie Wansa redesigned Ingleside into ACC's course. According to an announcement in an October 1947 issue of the *Phoenix Gazette*, the membership of the new Arizona Country Club planned a sprawling ranch-style clubhouse, designed by Gilmore and Varney. (Scottsdale Historical Society.)

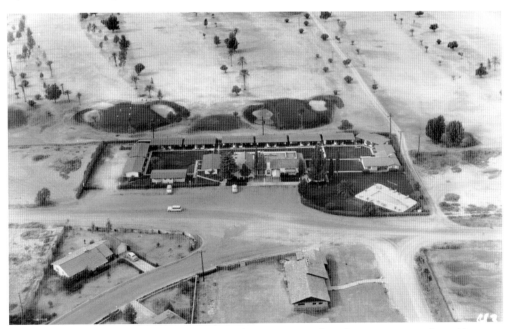

When the Arizona Country Club first opened, priority was placed on renovating the golf course. While the clubhouse was planned and financed, members often adjourned to the nearby Outpost Resort. The Outpost provided hotel and dining services on the European plan, with rates of $8 to $12 a day. A bonus to those staying or stopping by was entertainment by Mimi, a popular female lounge singer of the day. (Scottsdale Historical Society.)

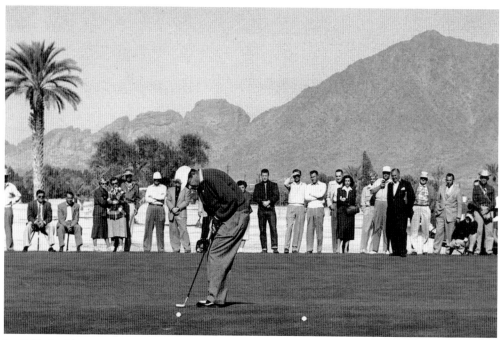

In 1955, the Phoenix Open PGA golf tournament began an every-other-year rotation between the Phoenix Country Club and the Arizona Country Club, bringing celebrities, golf professionals, and spectators to Scottsdale resorts, restaurants, and sidewalks. During the years the Phoenix Open played at ACC, Gene Littler (1955, 1959, 1969), Billy Casper (1957), Arnold Palmer (1961–1963), Rud Funseth (1965), Julius Boros (1967), Miller Barber (1971), and Bruce Crampton (1973) won the tournament. (Arizona Historical Foundation.)

The Arizona Country Club is Scottsdale's oldest private, traditional, parkland course with over 1,800 trees on the property. PGA Tour standout and local businessman Johnny Bulla redesigned the Arizona Country Club Golf Course in the 1960s, Tom Clark redesigned the layout in 1986, Gary Stevenson made changes in 1999, and Arizona-based golf course architect Gary Panks enhanced the course in 2006. Today the ACC hosts annual member tournaments, as seen here. (Arizona Country Club.)

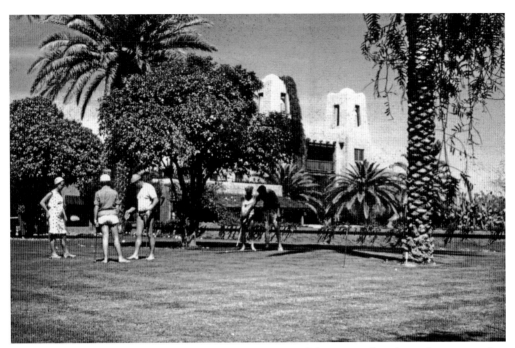

As golf gained in popularity in the 1950s, most Scottsdale resorts, hotels, and guest ranches installed putting greens on their grounds. Sylvia Evans opened the historic Jokake Inn on the south face of Camelback Mountain as a tearoom in 1926 and expanded it as an inn in 1928. After World War II, Jokake was further expanded and continued to operate until the 1970s, when the Phoenician Resort was built on its grounds. Jokake's main building still stands at the entrance to the Phoenician. (Scottsdale Historical Society.)

Architect and businessman R. T. "Bob" Evans built the Paradise Inn adjacent to the Jokake Inn in 1945. With the eastern end of Camelback Mountain as a stately backdrop, winter guests enjoyed the use of the inn's putting green. (Scottsdale Historical Society.)

The Paradise Inn, opened in 1945 with special permission from the War Production Board, was described in the February 4, 1945, *Arizona Republic* as "a modern adaptation of Mediterranean style of architecture, with many step-backs in the floor plan to provide maximum exposure to the east and south. Thus it stretches out along the mountain slope several hundred feet." It included a heated swimming pool; tennis, badminton, shuffleboard, and croquet courts; a putting green; and horse stables. (Scottsdale Public Library.)

Seen here in 1959, Scottsdale radio personality Christopher King (also known as Bernard M. Kane, a Scottsdale High School teacher, at left) and businessman Fred Dittmer were among those who enjoyed using the putting green at the Paradise Inn in Scottsdale. The inn closed in the 1970s to make way for the Phoenician Resort. (Scottsdale Historical Society.)

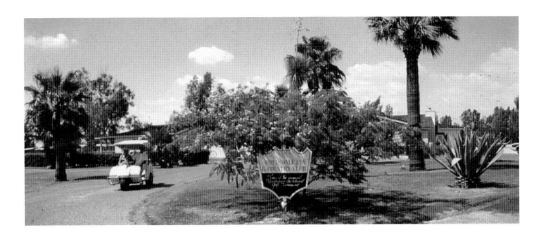

Sundown Ranch Country Club opened its 18-hole golf course for member play in December 1953. Prior to the golf course, the land was natural desert and grazing land for nearby ranches. Immediately to the east of the golf course was a new Arabian horse farm, BruSally Ranch, operated by Ed and Ruth Tweed. Located north of newly incorporated Scottsdale (1951), the Sundown Ranch course was sited along what is now Hayden Road, north of Shea Boulevard. The club also offered seasonal guest accommodations and homesites. A 1955 advertisement listed weekday greens fees at $2 and weekends and holidays at $3. Golf was free to the ranch's overnight guests. It was renamed Scottsdale Country Club around 1960, then Starfire at Scottsdale Country Club in 2001. It was also the home of the former Roadrunner Invitational Golf Tournament, as listed on the sign in the photograph above. (Above, Scottsdale Historical Society; below, author's collection.)

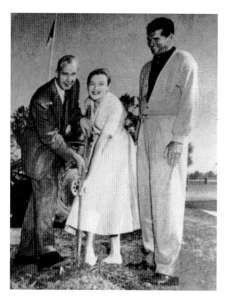

From the January 25, 1957, edition of the weekly *Arizonian* newspaper, this photograph shows Sundown Ranch Country Club president H. R. Buckman (left), Anne Kimball, and George Keyes, a PGA champion from Illinois, broke ground for the new clubhouse, which was expected to be complete by March 1957. (Mae Sue Talley, publisher, the *Arizonian*.)

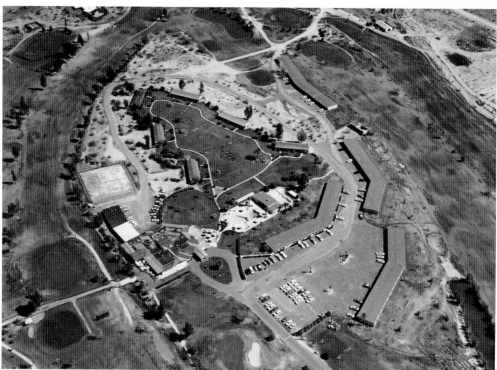

According to *The Bob Herberger Story* by Jim Smith, Herberger purchased Sundown Ranch Estates in March 1955, "which consisted of 63 home sites surrounding Sundown Ranch Golf Club located five miles north of Camelback. Herberger Enterprises initially built a model home on Shea Boulevard and subsequently offered both lots and houses, completely finished, rather than just the lots themselves. The project was done in this way for its orderly development and for the retention of the surrounding beauty." (Scottsdale Historical Society.)

When the Sundown Ranch Golf Course opened in 1953, it was north of the incorporated limits of Scottsdale but was annexed in the 1960s when Scottsdale was expanding its land area in all directions. The course opened December 5, 1953, with a Pro-Am tournament in which PGA president Horton Smith was the special guest. Local golf professionals and champs also participated in the Pro-Am, as listed in the December 4, 1953, *Scottsdale Progress*: Willie Low, Willie Wansa, Al Zimmerman, Gray Madison, Pete Wansa, Milt Coggins, Tom Lambie, Red Allen, and Bob Goldwater. Sundown Ranch/Scottsdale Country Club was one of several courses in the Scottsdale area that benefitted from the advent of motorized golf carts, which at first had only three wheels, were open air, and were guided by either a steering wheel or a tiller-style device. (Both Scottsdale Historical Society.)

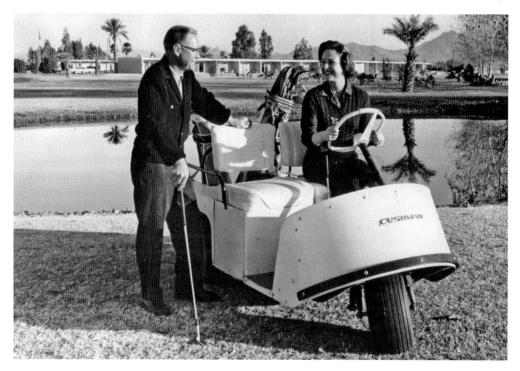

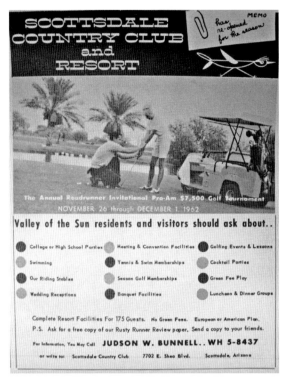

An announcement in the September 4, 1953, *Scottsdale Progress* stated that the Sundown Ranch Golf Course "is being built by Sundown Ranch, a corporation owned by William Guse of Detroit, Oliver F. Burnett, Jr. of Arizona and the Jervis B. Webb Estate of Detroit . . . Joseph Mayo, builder of the famous Inverness course in Toledo, Ohio; Cypress Point, Delmonte, California; the Navy Marine club at Pearl Harbor, T. H., and others, has been employed to lay out the course. John Hanley, recently of the Wickenburg Country Club, is now the greenskeeper of the Sundown club." George Mackey was the club professional when Sundown Ranch opened in 1953. This October 1962 ad from the *Arizonian* boasts no green fees for guests. (Mae Sue Talley, publisher, the *Arizonian*.)

During 1983, Scottsdale Country Club's golf course was completely redesigned by golf superstar Arnold Palmer and his associate, the golf course architect and director of design at Palmer Course Design Company, Ed Seay. Six lakes and over 60 sand traps were added to this, the first Arnold Palmer golf course in the Valley of the Sun. Later a third nine holes was added and the course was renamed Starfire at Scottsdale Country Club. (Scottsdale Historical Society.)

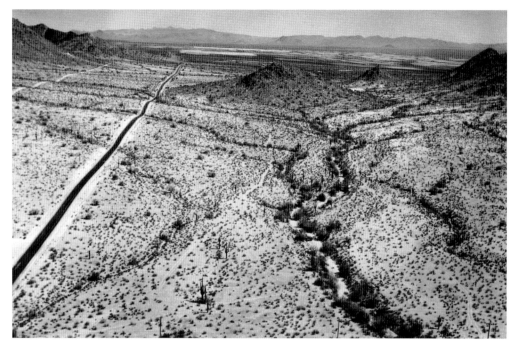

Tom and Brooks Darlington, Jim Beattie, Bobby Foehl, Emmette Graham, Sterling Hebbard, Bob Herberger, George Lane, Dan Norton, Fred Rencker, Ray Rubicam, Jack Stewart, Bill Weirich, and Harry Wilder first met in 1952 to plan an upscale private golf and country club in the Scottsdale area. Although the group considered buying land from Fowler McCormick's ranch, they easily selected an undeveloped parcel on the northeast corner of Lincoln Drive and Tatum Boulevard, since much of the land was donated by owners of the Camelback Inn in exchange for guest golf privileges. (Paradise Valley Country Club.)

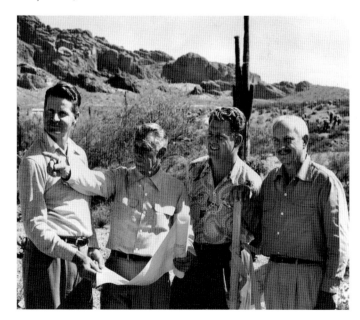

Ground was broken August 26, 1953, for the Paradise Valley Country Club (PVCC) Golf Course. This construction photograph shows, from left to right, local golf champion and businessman Gray Madison, golf course architect Lawrence Hughes, Al Padon, and charter PVCC member Ray Rubicam, a renowned advertising executive, planning the course layout. (Paradise Valley Country Club.)

Not wanting to wait for the course to be complete, Gray Madison tees up on the dirt of the 17th hole as Dan Norton (center) and Jim Beattie look on. Madison worked closely with architect Lawrence Hughes, particularly selecting the trees for the golf course. Al Zimmerman was hired as the first golf professional. The south nine was deemed playable in February 1954, with the course opened to members April 10, 1954, and celebrated with the club's first tournament and dinner dance. (Paradise Valley Country Club.)

Prospective members were bused from Phoenix and surrounding communities to the dusty but soon-to-be-glamorous Paradise Valley Country Club. Membership parties were also held at Scottsdale area resorts—such as the Casa Blanca, Camelback, Jokake, and Paradise Inns. (Paradise Valley Country Club.)

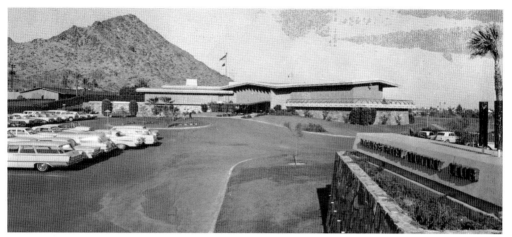

Paradise Valley Country Club began construction of its original clubhouse, "The Homestead," in August 1954. In February 1958, a newer, grander clubhouse opened. The opening party received rave reviews in PVCC member Eugene Pulliam's *Republic* and *Gazette* newspapers and from all who attended. *Republic* social reporter Maggie Savoy wrote, "Half the town was sardined into the new Paradise Valley Country Club's clubhouse Saturday night at its official opening party." (Paradise Valley Country Club.)

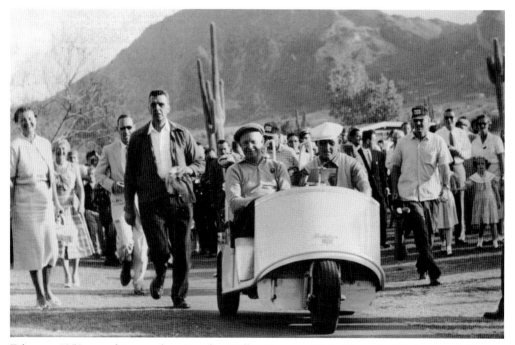

February 1958 was a big month at Paradise Valley Country Club. Not only did the new clubhouse open, but Pres. Dwight David "Ike" Eisenhower played golf there Sunday, February 23, 1958. He was the guest of *Arizona Republic/Phoenix Gazette* publisher Eugene Pulliam. President Eisenhower is shown here in the golf cart driven by PVCC head golf professional Al Zimmerman. (Paradise Valley Country Club.)

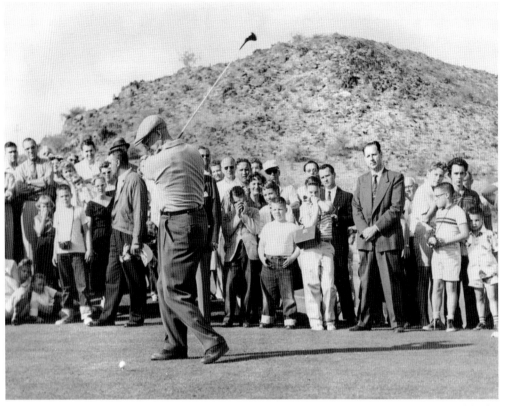

President Eisenhower, a lifelong avid golfer who owned a cottage at Augusta National and had a putting green outside the Oval Office at the White House, swings his club to the adoration of Paradise Valley Country Club members during his February 1958 game. Presidents Kennedy, Ford, and Reagan are also said to have played the course; no scores are available. (Paradise Valley Country Club.)

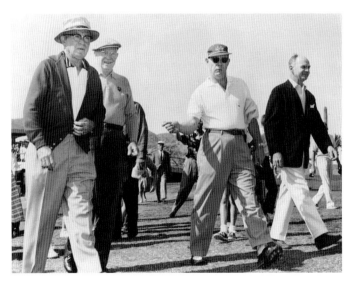

Paradise Valley Country Club member Eugene Pulliam (left) walks with his guest, president of the United States Dwight D. Eisenhower (second from left), along the club's links. Tom Kelland (center), PVCC member, newspaper executive, and son of author Clarence Budington Kelland, was also a member of Ike's foursome. (Paradise Valley Country Club.)

ADAPTING THE DESERT FOR GOLF: 1899–1960

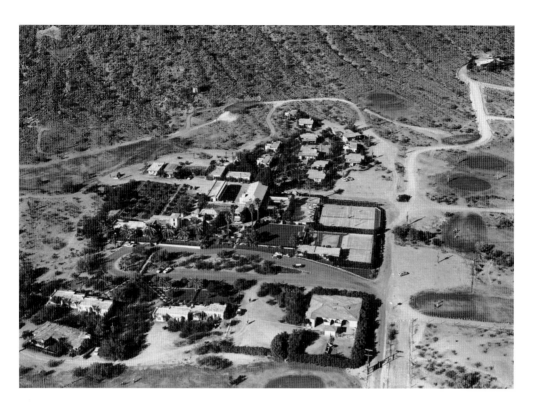

In 1956, owners of the Paradise Inn on Camelback Road converted 80 acres into a nine-hole, private golf course designed by David Gill. The former Daley home was remodeled into a clubhouse. Initially called the Paradise Inn Golf and Country Club, it was renamed the Valley Country Club. This aerial view of the Paradise Inn shows one fairway and green of the golf course along the bottom of the photograph. (Above, Robert Markow; below, Scottsdale Historical Society.)

Golf was just as popular with ladies as men at local courses and country clubs throughout the 1950s and 1960s. Shown here are members of the Women's Association of the Valley Country Club during their 1961 Captain's Cup Tournament as they appeared in a 1961 issue of the *Arizonian*. From left to right are Mrs. Robert Wilson, Mrs. George Mackey, and Mrs. Dennis Hock. (Mae Sue Talley, publisher, the *Arizonian*.)

Although it was a traditional and rather flat layout, guests of the Paradise and Jokake Inn enjoyed playing throughout the winter on the Valley Country Club Golf Course. A second nine was added in 1957. Several area high school golf teams played regularly on the course. Portions of the Valley Country Club course lie beneath the Phoenician Golf Course today. (Scottsdale Historical Society.)

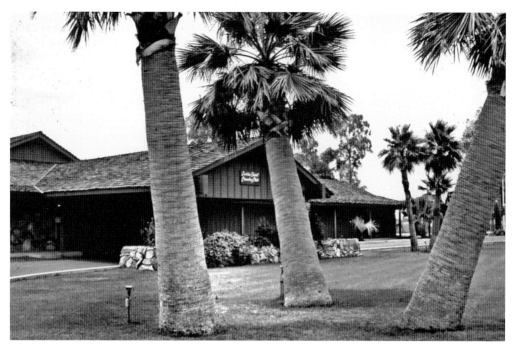

Indian Bend Country Club opened in late 1959 on the eastern outskirts of Scottsdale, along Pima Road, a half mile north of Indian Bend Road. Much of the course was located on land owned by the Salt River Pima-Maricopa Indian Community. The 18-hole course included a half mile of meandering canal, waterfalls, three lakes, and lots of trees. It had a driving range and fleet of electric golf carts. A 10,000-square-foot clubhouse was built in 1962. In 1965, greens fees were $3 on weekdays and $5 on weekends. (Scottsdale Historical Society.)

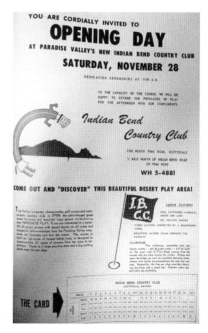

Indian Bend Country Club morphed into Roadrunner Golf Resort by the early 1970s and was the site for filming of an episode of *Swinging with the Stars* television series that featured players Bing Crosby and David Wayne. The golf course became the Pima Golf Course by the 1980s and was then renamed the Pavilion Lakes Golf Club in the 1990s. (Mae Sue Talley, publisher, the *Arizonian*.)

Jim Paul opened Mountain Shadows Resort on Lincoln Drive in the then-unincorporated town of Paradise Valley in 1958–1959. The resort was built on land that had been a working ranch. Arizona golf course architect Jack Snyder was selected to create an 18-hole executive-length golf course west of the resort in the northern foothills of Camelback Mountain. (Scottsdale Historical Society.)

Mountain Shadows included a 100-room resort, executive-length 18-hole golf course, tennis courts, and Mountain Shadows East, a home development along the golf course. In the early 1960s, builder Jim Paul sold Mountain Shadows to Del Webb, who operated the inn for many years. Marriott bought the resort in the early 1980s; the resort closed in September 2004. Redevelopment plans were pending in early 2008; however, the golf course remained open. (Scottsdale Historical Society.)

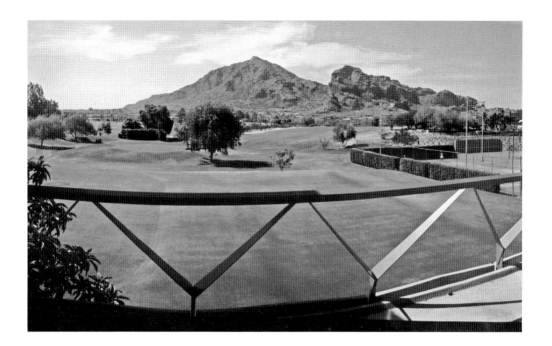

Whether on the golf course or at the pool, guests at Mountain Shadows during its 45-year run as a resort always had a magnificent view of Camelback Mountain. Based on the early success of home sales at Mountain Shadows East, Jim Paul developed Mountain Shadows West, adding over 50 homes along the golf course. Many who had stayed at the resort and played the course bought homes along the fairways as seasonal or year-round residences. (Both Scottsdale Historical Society.)

Despite its shorter length, Mountain Shadows Golf Course hosted numerous tournaments, particularly for juniors, seniors, and ladies. The resort was also a favorite place for movie stars and celebrities—Bob Hope, Sammy Davis Jr., John Wayne, Liz Taylor, the McGuire Sisters, Jack Benny, Don Ameche, and others. (Scottsdale Historical Society.)

After the resort closed in 2004, residents and scores who enjoyed playing the Mountain Shadows Golf Course rallied to save it from closure or redevelopment. (Author's collection.)

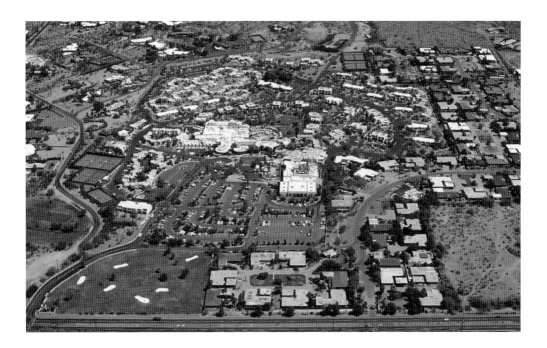

Camelback Inn, opened in 1936 by Jack Stewart and John C. Lincoln, has always offered its guests some form of golf. In the early days, guests could play pitch and putt at "Quial's Hollow" on the resort's front lawn, which faced Lincoln Drive (lower left corner of the photograph above). During the 1950s and 1960s, inn guests could play at Paradise Valley Country Club. After Marriott purchased the Camelback Inn, two 18-hole championship golf courses were built nearby for inn guests and the general public. (Both Scottsdale Historical Society.)

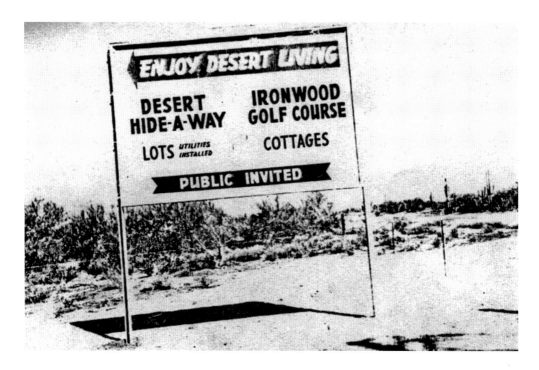

Unlike Scottsdale's modern-day, poshly appointed country clubs and championship courses, the Ironwood Golf Course in the desert north of Scottsdale was a rough-and-tumble, au naturel course established in the late 1950s. As this 1964 sign depicts, one could buy a home nearby and enjoy both golf and the open desert. (Above, City of Scottsdale; below, Scottsdale Room, Scottsdale Public Library.)

Ironwood Golf Course was a nine-hole, rustic desert layout near Sixty-second Street and Jomax Road north of Scottsdale in a yet-to-be-incorporated area. It was golf for those not needing fancy amenities. The ball-washer in the photograph below was typical of those found on courses in the 1960s. Desert land surrounding the course was often the scene of cookouts and parties. (Both Scottsdale Historical Society.)

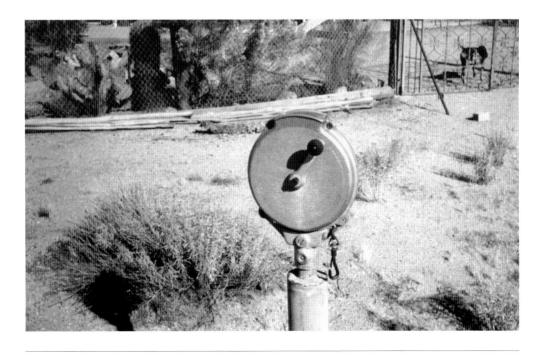

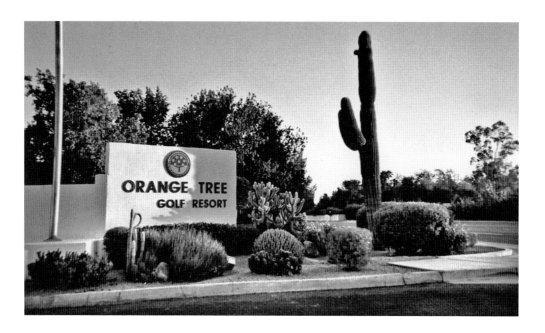

Regrettably, many private facilities were not welcoming to minority golfers during the early years of golf in the Valley of the Sun. There were, however, notable exceptions. City-operated Encanto Park Golf Course in Phoenix was one of the first in the valley to welcome minorities. The Arizona Biltmore was also an open facility. In 1957, PGA champion and local businessman Johnny Bulla designed the golf course for the predominantly Jewish Century Country Club. Located on Fifty-sixth Street between Shea Boulevard and Cactus Drive, it was renamed Orange Tree in 1977 and became a public, daily-fee course and resort. (Both author's collection.)

ADAPTING THE DESERT FOR GOLF: 1899–1960

The first golf team at Scottsdale High School was organized in 1954 and coached by William Kelley. His 1956 team shown here included, from left to right, Steve Curtis, Reese Verner, Bill Fannin, Bill Flickinger, Phil Schneider, Tom Dooley, and Bill Baugh. Schneider and Kelley recall that the team played at Sundown Ranch, Arizona Country Club, Encanto, Wickenburg, and El Rio in Tucson. Golf was added to the girls' physical education program at Scottsdale High in 1960. (Scottsdale High School 1956 Camelback yearbook image, courtesy of Phil Schneider Jr.)

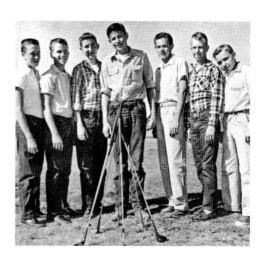

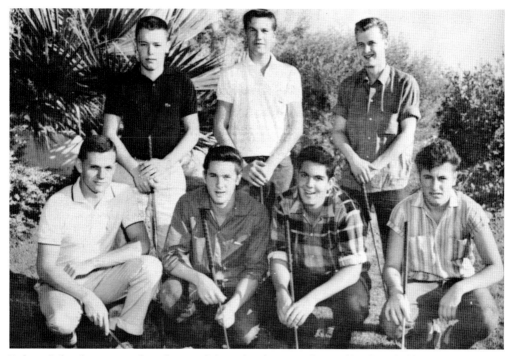

Judson School, a private boarding and day school in Paradise Valley founded by George Judson in 1928, began competitive golf in the 1950s. The 1959 Judson golf team included, from left to right, (first row) Phil Schneider, Bob Brazer, Ralph Applegate, and Mike Reinmund; (second row) Port McKinnon, Tod Buckman, and Joe Alvarez. Phil Schneider recalled that the team played at Indian Bend, Century, Valley, and Sundown Country Clubs. Judson School closed in 2000. (Judson School Cactus 1959 yearbook image, courtesy of Phil Schneider Jr.)

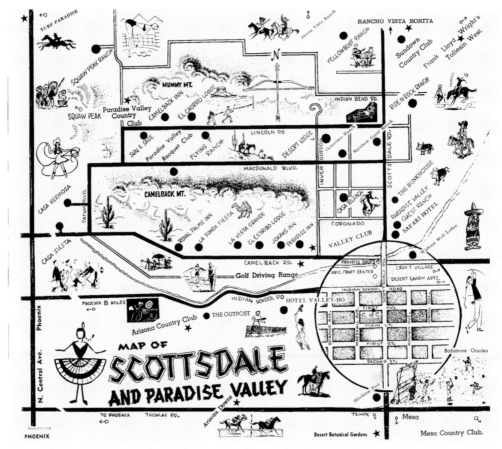

During the 1950s, guest ranches and car-oriented resort hotels popped up throughout the Scottsdale area. To meet the demand of travelers, several public and private golf courses also opened. This 1950s map shows the Arizona Country Club (1946), Sundown Ranch Country Club (1953), Paradise Valley Country Club (1954), and Valley Club (1956), as well as a golf driving range along Camelback Road. Resorts like Casa Blanca, the Camelback Inn, and the Paradise Inn also included putting greens on their grounds. (Scottsdale Area Chamber of Commerce.)

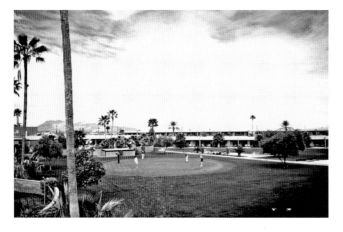

Postwar resort hotels in Scottsdale, like the Safari Hotel when opened in 1956, often included a putting green where guests could hone their skills. Resorts also made arrangements with local courses and private golf clubs to get tee times for guests. (Scottsdale Historical Society.)

2

ADAPTING GOLF

TO THE DESERT

1960 – 2008

In the 1960s, the nation's president, Ike Eisenhower, was an avid golfer. Golf was on television; in fact, an episode of Shell Oil Company's *Wonderful World of Golf* was filmed on a Scottsdale golf course. Television made celebrities out of golfers like Arnold Palmer, who rewarded his local fans with three consecutive wins in the early 1960s at the Phoenix Open. Ike's interstate highway system and the growth of car-friendly hotels, guest ranches, and resorts in Scottsdale made travel for golf a growing trend.

When Scottsdale incorporated in 1951, its land mass was less than 1 square mile. During the 1950s, 1960s, 1970s, and 1980s, the city grew in all directions, ending up with over 185 square miles of territory from its last major annexation in 1984. More land allowed more golf courses.

Regarding water, there was either not enough of it or too much of it in the case of the Indian Bend Wash, which ran north-south for miles and, when flooded, cut Scottsdale in half. The U.S. Army Corps of Engineers planned to build a concrete channel flood-control system. But residents and city officials saw a better solution. According to a City of Scottsdale publication, the design of the Villa Monterey Golf Course demonstrated that a grass-lined channel could effectively control erosion and provided a natural escape for floodwater to protect nearby homes. The Indian Bend Wash greenbelt concept eventually led to construction of three additional golf courses in the wash, along with parks, lakes, and ball fields.

Development of the McCormick's former ranch into Scottsdale's first master-planned community started a trend of building cities-within-the-city that included a golf course centerpiece. Arizona's Groundwater Act passed in the 1980s led Scottsdale to require new golf courses to irrigate with reclaimed water. The desert golf concept pioneered at Desert Highlands in 1983 by Jack Nicklaus and Lyle Anderson demonstrated that water could be drastically reduced by keeping the natural contours and washes of the desert, which added to the challenge and play of the course.

Scottsdale residents became concerned about their disappearing Sonoran Desert landscape. Eco-sensitivity spurred new developments to be in harmony with Scottsdale desert and terrain, flora, fauna, and climate.

SCOTTSDALE **GOLF COURSES**

From challenging championship to fun pitch 'n putt courses, Scottsdale provides an unparalleled variety of exciting golfing pleasure in Arizona's famed Valley of the Sun. Upon request, almost all courses will accord temporary playing privileges to non-guests, non-members.

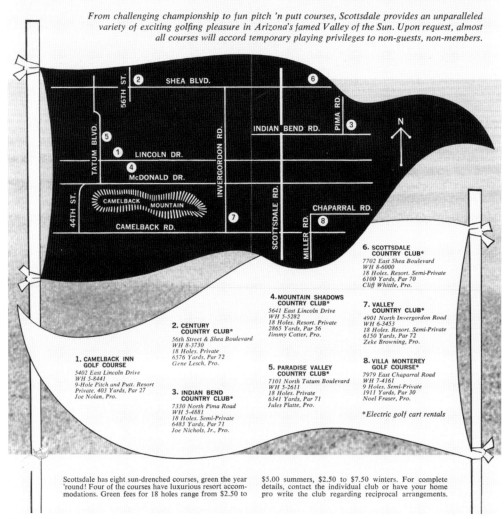

6. SCOTTSDALE COUNTRY CLUB*
7702 East Shea Boulevard
WH 8-6000
18 Holes. Resort. Semi-Private
6100 Yards, Par 70
Cliff Whittle, Pro.

4. MOUNTAIN SHADOWS COUNTRY CLUB*
5641 East Lincoln Drive
WH 5-5282
18 Holes. Resort. Private
2865 Yards, Par 56
Jimmy Cotter, Pro.

7. VALLEY COUNTRY CLUB*
4901 North Invergordon Road
WH 6-3453
18 Holes. Resort. Semi-Private
6150 Yards, Par 72
Zeke Browning, Pro.

2. CENTURY COUNTRY CLUB*
56th Street & Shea Boulevard
WH 8-3730
18 Holes. Private
6576 Yards, Par 72
Gene Lesch, Pro.

1. CAMELBACK INN GOLF COURSE
5402 East Lincoln Drive
WH 5-8441
9-Hole Pitch and Putt. Resort
Private. 403 Yards, Par 27
Joe Nolan, Pro.

5. PARADISE VALLEY COUNTRY CLUB*
7101 North Tatum Boulevard
WH 5-2611
18 Holes. Private
6341 Yards, Par 71
Jules Platte, Pro.

8. VILLA MONTEREY GOLF COURSE*
7979 East Chaparral Road
WH 7-4161
9 Holes. Semi-Private
1911 Yards, Par 30
Noel Fraser, Pro.

3. INDIAN BEND COUNTRY CLUB*
7330 North Pima Road
WH 5-4881
18 Holes. Semi-Private
6483 Yards, Par 71
Joe Nichols, Jr., Pro.

**Electric golf cart rentals*

Scottsdale has eight sun-drenched courses, green the year 'round! Four of the courses have luxurious resort accommodations. Green fees for 18 holes range from $2.50 to $5.00 summers, $2.50 to $7.50 winters. For complete details, contact the individual club or have your home pro write the club regarding reciprocal arrangements.

This golf map from the third annual Scottsdale Seniors Golf Fiesta, sponsored by the Scottsdale Resort Association and the Scottsdale Area Chamber of Commerce, shows eight golf courses in 1965. Held in April annually during the 1960s, the Golf Fiesta lured golfers 55 and over to stay and play in Scottsdale. (Scottsdale Area Chamber of Commerce.)

Butler Homes received approval from the City of Scottsdale to develop what the newspaper called a "Millionaire's Sun City" on a 181-acre tract east of Miller Road and south of Coronado Drive in 1961. Eighty-one acres that extended across the flood-prone Indian Bend Wash would be developed into an 18-hole golf course (crossing what is now Hayden Road). The name of the new development was Villa Monterey. According to the February 21, 1961, *Scottsdale Daily Progress*, "The company is working with the Maricopa County Flood Control district to design the course in such a way that all but top flood level water will be drained through swales provided as a part of the course. The firm of Ralph Haver and Associates has been employed to design the home units, which will be in Spanish Colonial Style." (Above, author's collection; below, Mae Sue Talley, publisher, the *Arizonian*.)

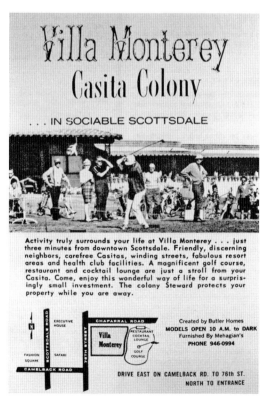

The Villa Monterey Golf Course featured a clubhouse with dining room and cocktail lounge, convenient for golfers as well as those living in the Villa Monterey Casita Colony. In the early 1980s, it reopened as a nine-hole track, with more townhomes and Hayden Road taking up some of the 18-hole course's former layout. In the late 1980s, the Scottsdale Culinary Institute took over the Villa Monterey clubhouse as its headquarters and teaching facility, shown here. After brief operation in the late 1990s as a golf course for juniors and seniors, Villa Monterey closed for good in the early 2000s and is slated to become a City of Scottsdale park in late 2008. (Author's collection.)

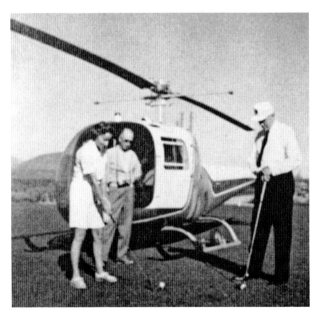

K. T. Palmer and Tom Darlington founded the town of Carefree north of Scottsdale in 1957. A few years later, they opened an 18-hole golf course in their town, designed by Red Lawrence, that is considered the forerunner of desert golf. Desert Forest Golf Club opened February 4, 1962. As recorded by the February 9, 1962, edition of the *Arizonian*, Mrs. Bernard (Carolyn Goldwater) Erskine and club president K. T. Palmer were joined by Gov. Paul Fannin, who arrived by helicopter at the new course. (Mae Sue Talley, publisher, the *Arizonian*.)

From left to right, Century Country Club pro Tom Lambie, Paradise Valley Country Club pro Kenny Kier, Desert Forest pro Stan Graff, and PGA champion Johnny Bulla get a preview of the Desert Forest course prior to opening day in February 1962. With no clubhouse or country club, Desert Forest was pure golf. Members often adjourned to the nearby Carefree Inn after their games. Desert Forest has hosted several U.S. Golf Association tournaments over the years and was a favorite of Tom Weiskopf's for tuning up his game before a tournament. (Mae Sue Talley, publisher, the *Arizonian*.)

As golf courses moved away from established areas and into the pristine desert, golfers often encountered wildlife on the fairways and greens. Deer, javelina, coyote, and bobcat sightings were common. Many courses posted rattlesnake warning signs to remind golfers, especially tourists, to tread carefully when searching for their ball in the desert. (Author's collection.)

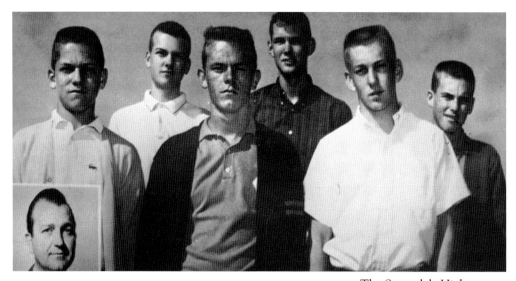

The Scottsdale High School golf team continued to field excellent players throughout the 1960s. As these yearbook photographs show, future U.S. senator and vice president of the United States Dan Quayle was a member of the 1963 golf team. In the above photograph from left to right are (first row) coach James Reuter (inset), Jack Williams, Bob Ingraham, and John Bohon; (second row) Dennis Karr, Doug Kruidner, and Danny Quayle. Dan's family moved back to Indiana, where he finished high school and college before beginning his law and political career. The Quayles moved back to the Scottsdale area in 1996. Since then, Quayle has been a popular guest at Pro-Ams and golf tournaments. (Both Scottsdale High School Camelback yearbook.)

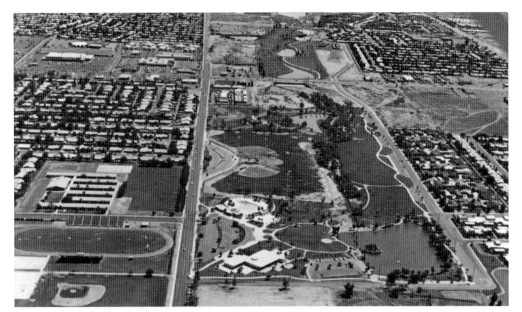

Coronado Golf Course opened its nine holes at Seventy-sixth Street and Thomas Road in November 1965 across from Coronado High School. The course was a collaboration among owner Tom Lambie, George Sweeney, and Ken Jones, with Oran Love as a teaching pro. Jack Snyder was the course architect. Opening ceremonies included an exhibition match pairing Lambie and Love against Johnny Bulla and Stan Graff of Desert Forest Golf Club. This aerial view shows the course just right of center. (City of Scottsdale.)

Coronado Golf Course owner Tom Lambie, former pro at Century Country Club, acquired the land for Coronado from Henry Galbraith. Located in the flood-prone Indian Bend Wash, it had been a thicket of desert brush and a favored dumping ground for all kinds of junk. For many years, the *Scottsdale Daily Progress* sponsored a golf tourney for junior boys and girls at Coronado. With affordable greens fees and a lighted driving range for night use, Coronado Golf Course was a success and remains a favorite of budget-minded golfers in 2008. (Scottsdale Historical Society.)

The City of Phoenix opened Papago Municipal Golf Course in 1963, designed by William F. "Bill" Bell, son of designer Billy Bell. Located in historic and scenic Papago Park, the 18-hole championship course included lakes, trees, and spectacular views of the red-rock Papago Buttes. Arizona State University and PGA star Billy Mayfair and LPGA star sisters Heather and Missy Farr all earned their stripes at Papago. At the affordable "muni," golfers created a long-standing tradition of lining up in their cars before dawn to get a tee time, thus creating "The Line." This produced many friendships and a few disappointments over the years and continues today. After hosting many national and regional tournaments over the years, Papago lost some of its luster as resort and pricey daily-fee courses offered an array of luxurious amenities and state-of-the-art golf facilities. In 2008, the City of Phoenix decided to give Papago a total makeover; more history will surely be made at this popular course. (Both author's collection.)

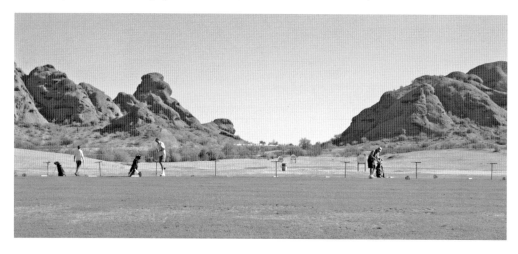

The Executive House Arizonian, opened in fall 1961, included a putting green in its center courtyard. Local ladies flocked to the hotel's coffee shop in the 1970s to watch Ephram Zimbalist Jr. practice his putting during breaks in the filming of an episode of his popular *FBI* television series. The hotel has gone through several makeovers and name changes—from Sunburst to Caleo to FireSky. (Scottsdale Historical Society.)

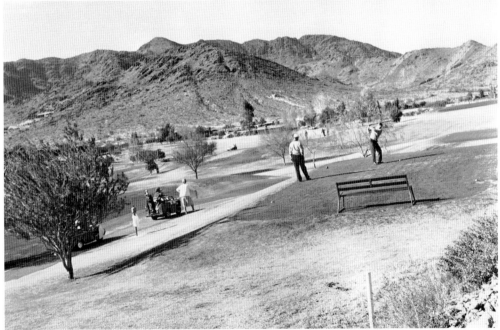

During its eight-year run on television during the 1960s, Shell Oil's *Wonderful World of Golf* filmed at least once in the Scottsdale area. A Paradise Valley Country Club member remembers a shoot-out between "Porky" Oliver and Mike Souchek and huge cameras being toted around the course on the backs of station wagons. This view shows a non-televised match among friends at PVCC. (Scottsdale Historical Society.)

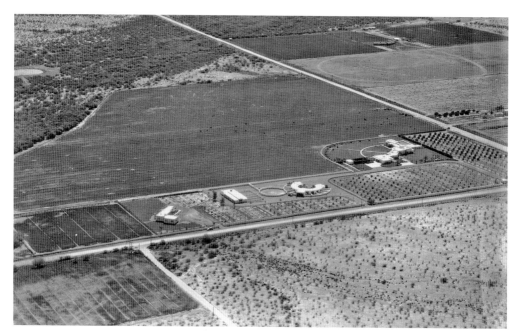

McCormick Ranch, a former Arabian horse and cattle ranch established in the 1940s by International Harvester chairman Fowler McCormick and his wife, Anne, became the site of Scottsdale's first master-planned community, also called McCormick Ranch, developed in the early 1970s by Kaiser Aetna. This aerial view shows the McCormicks' ranch headquarters at the northeast corner of Scottsdale and Indian Bend Roads. (Scottsdale Historical Society.)

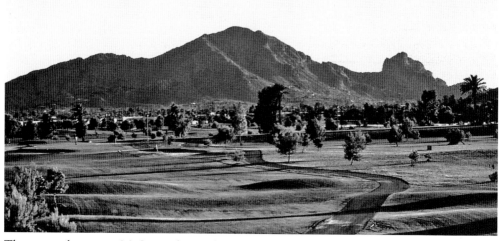

The city-within-a-city McCormick Ranch opened its first of two golf courses, the Palm Course designed by Desmond Muirhead, in 1972, with awesome views of Camelback Mountain to the southwest (shown). McCormick Ranch planning director George Fretz, who was the City of Scottsdale's planning director in the 1960s, helped ensure that buildings were set back and roads were aligned throughout McCormick Ranch to maintain unobstructed views of Camelback Mountain to the southwest and the McDowell Mountains to the northeast. (Scottsdale Historical Society.)

Desmond Muirhead designed a second 18-hole course for McCormick Ranch, the Pine Course, which opened in 1973. Both Pine and Palm daily-fee public courses became popular places to hold corporate and organizational golf tournaments, making McCormick Ranch the "home of the scramble." For many years, the American Airlines Golf Classic took place at McCormick Ranch. (Author's collection.)

This aerial view shows the McCormick Ranch clubhouse (center), just south of McCormick Parkway, which runs from left to right across the top of the photograph. A large lake on the east side of Scottsdale Road was created to help irrigate the golf courses. (Scottsdale Historical Society.)

In 1972, after Marriott assumed ownership of the Camelback Inn, the inn built its first golf course. Red Lawrence initially designed the 18-hole Padre Course; it was redesigned by Arthur Hills and renamed the Resort Course. In 2007, it reverted back to its original Padre name. (Scottsdale Historical Society.)

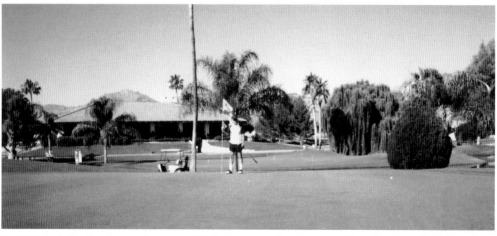

In 1978, Jack Snyder designed a second 18-hole course for Marriott's Camelback Golf Club, calling it the Indian Bend Course. After a redesign by Arthur Hills, it was renamed the Club Course; however, it reverted back to its historic Indian Bend name in 2007. Many celebrity tournaments are held on the course each year, and the Scottsdale Rotary Club held its weekly luncheons in the clubhouse for years. (Author's collection.)

In 1969, Arizona-based golf course architect Red Lawrence designed the first nine holes of the Boulders Golf Course in Carefree, north of Scottsdale. The nearby Carefree Inn included golf at the Boulders as part of its "Carefree Caper" weekend package, priced at $25 (golf and overnight stay) in 1976. (Author's collection.)

Jay Morrish, in one of his first design projects after leaving the Jack Nicklaus design group, reconfigured the Boulders course, adding another nine holes. (Scottsdale Convention and Visitors Bureau.)

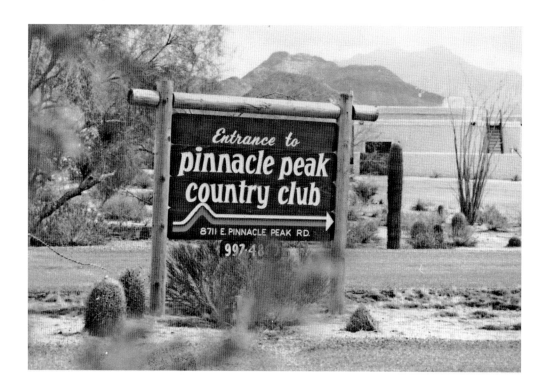

Jerry and Florence Nelson began acquiring land in the Pinnacle Peak area north of Scottsdale in 1969–1970. Their first development was Pinnacle Paradise, which included an 18-hole golf course designed by Dick Turner. When it opened in 1976 just south of Pinnacle Peak Road between Pima and Miller Roads, Pinnacle Peak Country Club was the first 18-hole championship course in an area now home to over a dozen world-renowned courses. Developer Jerry Nelson is second from the left in the image below. (Both Pinnacle Peak Country Club.)

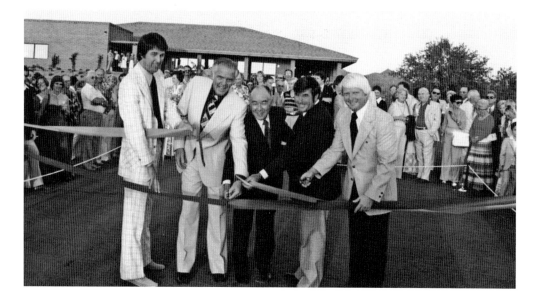

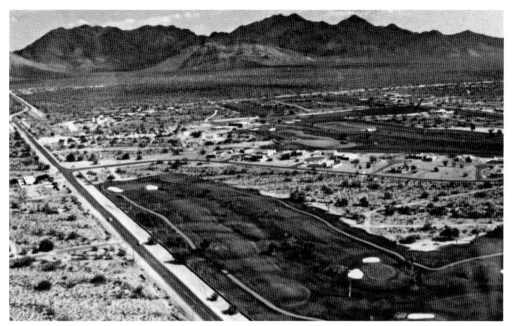

Member owned since 1976, Pinnacle Peak Country Club Golf Course is a walkable, parkland-style layout. It was the first of five Scottsdale golf courses developed by Jerry Nelson, known for his environmental sensitivity and water resourcefulness as well as keen business acumen. As this late-1970s photograph shows, the area was mostly undeveloped, with virtually no built environment east and north of the golf course. Pima Road runs diagonally east from the bottom of the image. (Pinnacle Peak Country Club.)

When Nelson began developing Pinnacle Paradise in the early 1970s, it was located in unincorporated county land north of Scottsdale with no water service. He drilled for water until he found a deep well, then was assured he could provide water for his planned residences, businesses, and golf course. Lakes built on the course helped provide water for irrigation. Dick Phelps redesigned the course in 1996. (Pinnacle Peak Country Club.)

As the City of Scottsdale worked with the U.S. Army Corps of Engineers to tame the flood-prone Indian Bend Wash (below), foresighted planners decided it would be better for Scottsdale to design it as a multi-mile series of parks and recreational facilities rather than a concrete-lined channel. Incorporated in the design were several nine- and 18-hole golf courses—Coronado, Continental, Villa Monterey, and Silverado. Continental (left) opened its 18 holes on the north side of Osborn Road in 1977, designed by Greg Nash and Jeff Hardin. (Both Scottsdale Historical Society.)

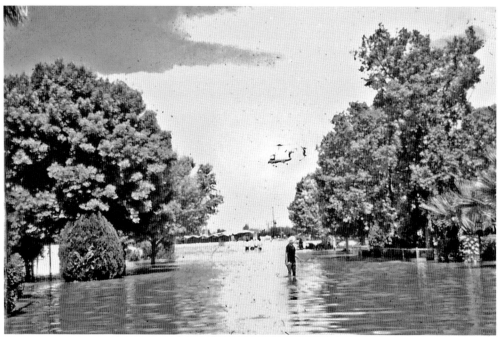

Developer Lyle Anderson enticed golf legend and course designer Jack Nicklaus to create a championship golf course on the south side of Pinnacle Peak Mountain that would be the center point of Anderson's Desert Highlands community. Together they made golf history by introducing the target desert golf concept, now a mainstay of Scottsdale and Southwestern golf course architecture. The photograph below shows the dramatic drop of the first hole and its sweeping view of the valley. Anderson and Nicklaus went on to collaborate on Scottsdale's largest golf course community, Desert Mountain, building six championship courses on the northernmost site in Scottsdale. (Right, *Scottsdale Airpark News*; below, the Lyle Anderson Company.)

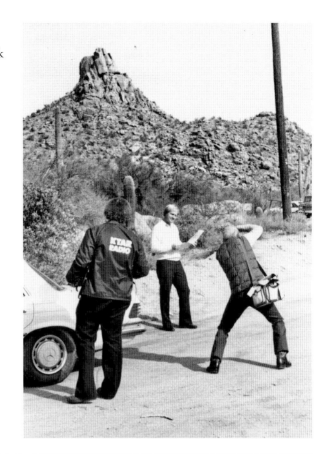

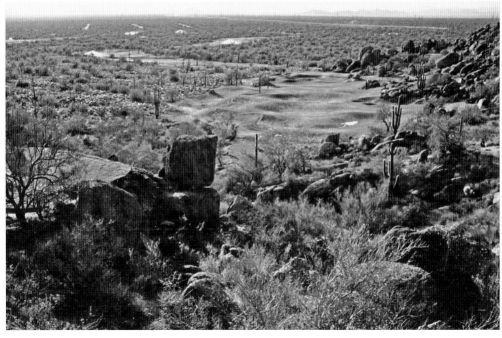

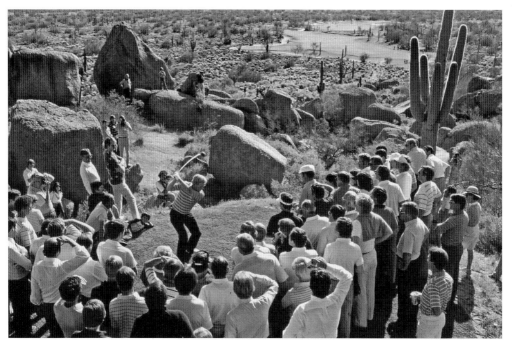

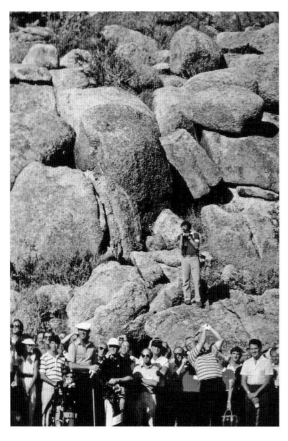

When the first nine holes at Desert Highlands were finished in April 1983, course designer Jack Nicklaus asked his fellow Ohio State University friend Tom Weiskopf to join him in an exhibition for Desert Highlands members and their guests. Singer Glen Campbell and local golf pros were in the exhibition gallery, often perching on humongous boulders to see the PGA stars in action. The draw was the celebrity golfers; there was no clubhouse or other facility yet built on the property—except for a very popular sales office, where parties were thrown nearly every night. Nicklaus and Weiskopf came back for another exhibition in October 1983 to showcase the just-completed back nine holes. A month later, the inaugural Skins Game was televised from Desert Highlands, pitting Nicklaus against Arnold Palmer, Gary Player, and Tom Watson. (Above, Desert Highlands Golf Club Association; left, the Lyle Anderson Company.)

In addition to helping Jack Nicklaus develop the target desert golf concept at Desert Highlands, Lyle Anderson also came up with another golf innovation for his new community—the first 18-hole putting course in North America. Similar to the Himalayas Course at St. Andrews in Scotland, the Desert Highlands Putting Course was designed by Scottsdale-based architect Gary Panks. (The Lyle Anderson Company.)

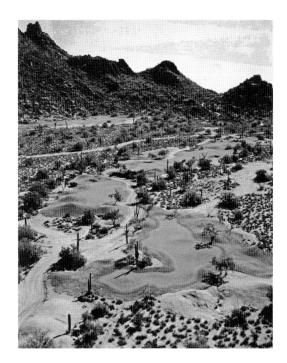

Throughout the design of the golf course and facilities at Desert Highlands, Lyle Anderson, his initial general partners Jim Bartlett and Dick Bailey, Jack Nicklaus and his design team of Jay Morrish and Scott Miller, planner Gage Davis, and clubhouse designer Bill Zmistowski adhered to the mantra, "Above all, protect the site." Whenever possible, grading and excavating were avoided and the golf course, roads, and buildings were constructed around natural features and plants. The halfway house on the Desert Highlands Jack Nicklaus Signature Golf Course shown here incorporates a super-sized boulder into its design. (Author's collection.)

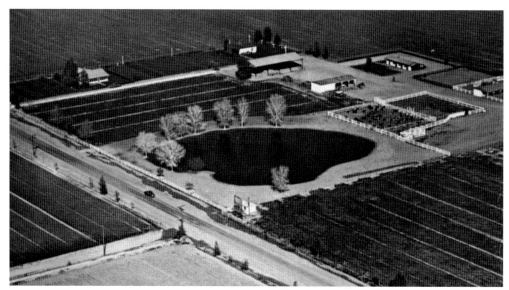

By the 1950s, Minnesota businessman Daniel Gainey had established a cattle and Arabian horse ranch north of McCormick's ranch on Scottsdale Road (pictured here in 1959). After his death in 1979, the land was sold for development of Gainey Ranch, a master-planned community of upscale residences, a Hyatt resort, and a 27-hole golf course. Markland Properties was the developer. (Scottsdale High School Camelback yearbook.)

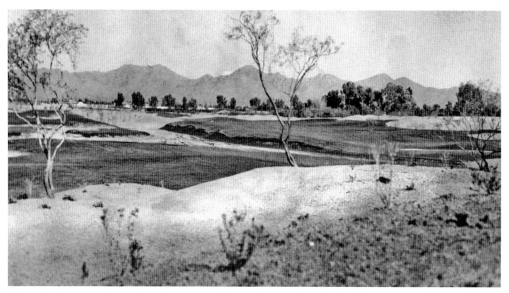

Mike Poellot was selected to design the 27-hole Gainey Ranch Golf Course. Building a 27-hole track not only gave golfers variety and a challenge, it also provided potential homeowners more golf course properties to choose from. The Gainey Ranch Water Reclamation Facility was dedicated in 1984. It pioneered Scottsdale's commitment to conserve water resources by requiring all new golf courses to use reclaimed water for golf course irrigation. The Dunes Course is shown here under construction in 1984. (Scottsdale Historical Society.)

The Hyatt Regency Scottsdale Resort and Spa and adjoining Gainey Ranch Golf Club opened in 1986. Whether they played golf or not, resort guests could sit in the courtyard and savor the views of the swaying palms on the island green and the McDowell Mountains as a backdrop. The three nines of the Gainey Ranch course are named the Lakes, Dunes, and Arroyo Courses. (Hyatt Regency Scottsdale Resort and Spa.)

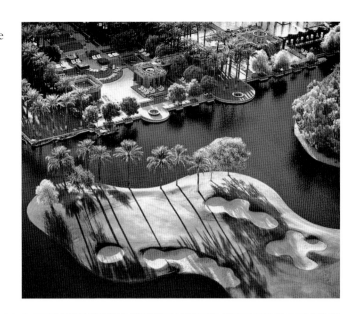

Developer Jerry Nelson selected the team of PGA champion and golf course designer Tom Weiskopf and former Nicklaus design associate Jay Morrish to lay out a new 18-hole desert-style course east of Pinnacle Peak at the base of what locals called "Boulder Mountain." Since Weiskopf had won the British Open in 1973 at Royal Troon, Nelson and his partners chose to call the new golf course, country club, and surrounding residential development Troon. The copper-topped Southwestern contemporary clubhouse won awards as soon as it opened. *Golf Digest* named Troon the Best New Private Golf Course in the Nation after it opened in 1986. (Author's collection.)

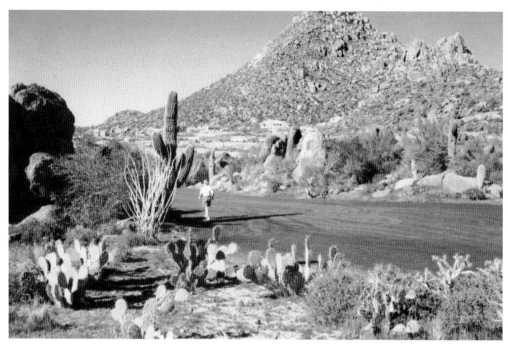

Weiskopf and Morrish designed the front nine of Troon Country Club's golf course on the north side of Happy Valley Road and the back nine on the south side. Hole 16, shown here, was named "The Gunsight" since a drive must be aimed to clear two boulder formations on either side of the tee boxes. The renamed Troon Mountain (formerly Boulder Mountain) is in the background. (Author's collection.)

Nearly every hole on the Troon Country Club Golf Course has a view of Pinnacle Peak. Designed in the target golf style, the course features many carries over desert vegetation and natural washes. The club hosted the 1990 U.S. Golf Association Mid-Amateur Championship, five Arizona Opens, and numerous charity golf tournaments. (Author's collection.)

Several sites in the valley were being considered as a location for a Tournament Players Club golf course when the PGA was expanding the concept in the early 1980s. With enthusiastic encouragement by then-Scottsdale mayor Herb Drinkwater and several members of city council, Scottsdale landed two 18-hole TPC golf courses and, with the Stadium Course, the new home for the Phoenix Open golf tournament. The courses broke ground in 1985 north of the Scottsdale Airport and the Central Arizona Project Canal and between Scottsdale and Pima Roads on previously undeveloped land. These photographs show the TPC clubhouse under construction in 1986. (Both *Scottsdale Airpark News*.)

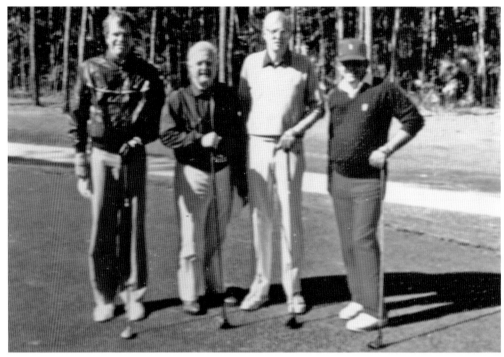

City of Scottsdale councilmen Jim Bruner (second from right) and Bill Walton (second from left), with City of Scottsdale senior staff members Carder Hunt (left) and Dave Harris (right), helped bring the Tournament Players Club Stadium golf course to Scottsdale. Bruner served as liaison with the PGA in negotiating acquisition of the course (and moving the Phoenix Open tournament to Scottsdale), while Walton served as chairman of the TPC Committee and negotiated acquisition of land for the golf course and adjacent Princess Hotel. Bruner, as chairman of the Maricopa County Board of Supervisors, cast the deciding vote to build a baseball stadium in Phoenix, thus landing a new Major League Baseball franchise, the Arizona Diamondbacks. Walton carded a hole-in-one on the 16th hole of the TPC Desert (now Champions) Course. (Bill Walton family.)

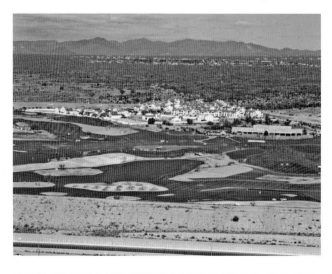

The design team of Jay Morrish and Tom Weiskopf were selected to create the two TPC courses—the Stadium Course, which would accommodate the thousands of spectators in the Phoenix Open galleries, and the Desert Course, a golfer-friendly companion course. Both courses were open by 1987, the same year the adjacent Scottsdale Princess Resort opened. (Scottsdale Historical Society.)

The TPC Scottsdale Stadium Course opened in December 1986, just weeks before a record crowd came to watch the greats of golf play in the January 1987 Phoenix Open. The Thunderbirds, host of the PGA Tour event, were pleased to have a new and larger venue for their annual event, allowing more money to be raised for local charities. Here Tom Watson plays in the Phoenix Open at TPC Scottsdale. (*Scottsdale Airpark News.*)

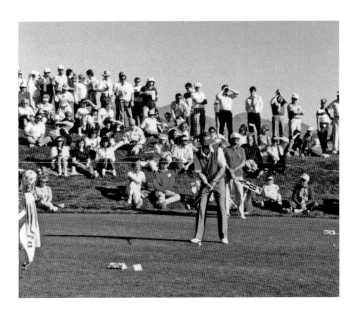

Prior to its opening in 1987, codesigner Tom Weiskopf said in a 1986 issue of *Scottsdale Scene* magazine, "What is so great about this project is that residents and visitors of this area . . . average golfers . . . will have an opportunity to play a course the pros play. There are many excellent courses in the Valley, obviously, but in most cases, unless you know somebody, you can't get on them. This course will be different, because for 51 weeks out of the year, this course will be for the public!" Weiskopf is shown here at the reopening of the Stadium Course in 1997 after he helped tweak the design. The Desert Course was redesigned in 2007 by Randy Heckenkemper and renamed the Champions Course. (Author's collection.)

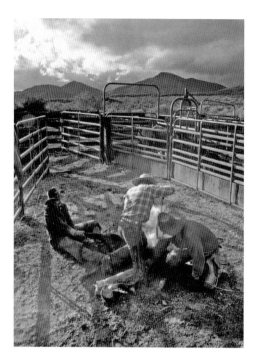

Building on the success of his Desert Highlands development, Lyle Anderson acquired huge tracts of land in the northernmost area of Scottsdale in the early 1980s and began development of Desert Mountain, which would eventually feature six Jack Nicklaus Signature golf courses. Much of the land had been used for cattle ranching, including a spread called Carefree Ranch. This photograph shows one of the last cattle roundups before development began in the mid-1980s. Desert Mountain also absorbed a short-lived golf course, Gambel Golf Links at the Ranch at Carefree, which opened in 1981. (Frank Zullo.)

Just as he had at Desert Highlands, course designer Jack Nicklaus made numerous visits to the Desert Mountain site to plan the most environmentally sensitive, water-conserving, and challenging golf courses possible. Seen wearing leather chaps to ward off cactus needles and rattlesnakes are, from left to right, Jack Nicklaus, Dick Frye, Scott Miller, and Phil Schneider; the fifth man in the back is unidentified. (The Lyle Anderson Company.)

Desert Mountain's Renegade Course opened in 1987, the Cochise Course in 1988, the Geronimo Course in 1989, the Apache Course in 1996, the Chiricahua in 1999, and the Outlaw Course in 2003, all designed by Jack Nicklaus. Here Nicklaus is at the podium, with his golf course development collaborator and close friend Lyle Anderson in the center of the photograph at the September 1994 ground-breaking for the Apache Course. Then–Scottsdale city councilwoman (and later mayor) Mary Manross is standing at right. (Author's collection.)

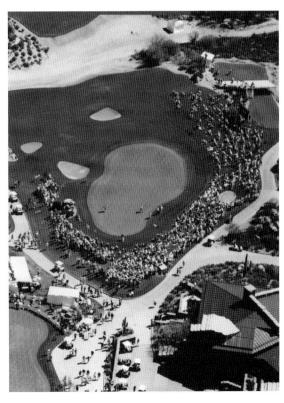

In April 1989, Desert Mountain's Renegade Course hosted The Tradition, one of the four majors on the Senior PGA golf tour. Don Beis won The Tradition tournament that year; course designer Jack Nicklaus won it four times before the tournament moved to another Anderson-Nicklaus golf community, Superstition Mountain, in 2002. Here spectators watch the pros putt out on the 18th hole at the 1995 Tradition. (The Lyle Anderson Company.)

Like the proverbial Phoenix bird, The Phoenician Golf Course arose from what remained of the Valley Country Club, but with much more pizzazz. The ultra-posh Phoenician Resort replaced the Jokake and Paradise Inns on the southeastern slope of Camelback Mountain in the early 1980s and had Ted Robinson Sr. and Homer Flint design three nines—the Oasis, Desert, and Canyon. The Robb Report named The Phoenician one of the four Best Golf Resorts, and *Golf Digest* ranked it in the Top 75 Golf Resorts in America. (The Phoenician.)

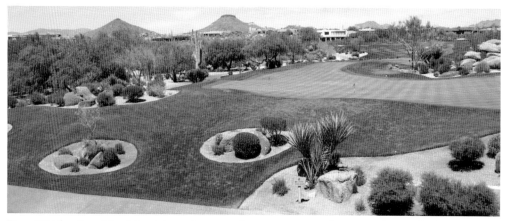

Tom Weiskopf and Jay Morrish again teamed up to create a championship 18-hole desert golf course for Jerry Nelson, this time on the north side of Pinnacle Peak. Troon North Golf Club's Monument Course, shown here, opened in March 1990 as a daily-fee public course. A second 18 holes, the Pinnacle Course, opened in 1995. Turning the natural habitat and terrain into golfers' challenges, they designed the course to offer incomparable scenery, with Pinnacle Peak to the south and Browns Mountain (the flat-topped mountain at center) to the north. Both courses are consistently praised by *Golf Digest*. The worldwide golf management company Troon Golf got its start at Troon North in 1990. (Author's collection.)

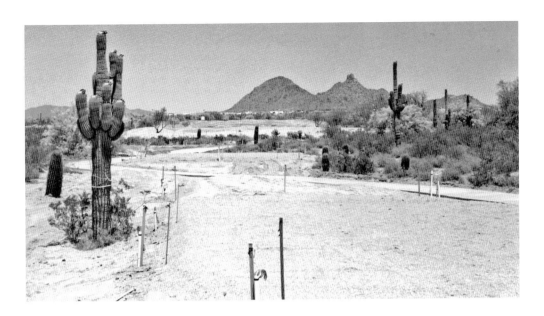

The Talon Course was the centerpiece of the new Grayhawk community when it opened in December 1994. The team of Gary Panks and David Graham designed the 18-hole championship, daily-fee course west of Pima Road and along both sides of newly constructed Thompson Peak Parkway. An article in the December 2, 1995, *Scottsdale Tribune* listed Talon as Scottsdale's 21st golf course, encompassing 176 acres and including over 40,000 native plants. These photographs show the 16th hole on the Talon Course, during construction (above) and in play (below). A year later, the Tom Fazio–designed, 18-hole Raptor Course opened at Grayhawk. (Above, Grayhawk; below, Lonna Tucker.)

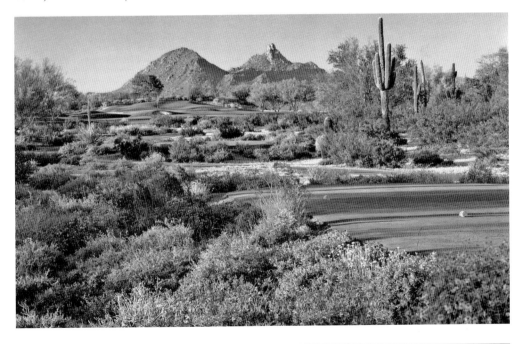

Less than a year after the Talon Course at Grayhawk opened, it hosted the Andersen Consulting World Championship of Golf on December 30 and 31, 1995. Television viewers throughout the world—many in snowy, cold climates—were enticed by the sunny views of Scottsdale and its desert golf challenges. These photographs show the construction (above) and finished island green 17th hole (below) on the Grayhawk Talon Course. Grayhawk named the first hole on the Talon Course "Farrview" in honor of LPGA star Heather Farr, who lost her battle with breast cancer while she was serving as Grayhawk's first "ambassador" of golf. Shortly after it opened, the Talon Course was ranked among the Top Ten You Can Play by *Golf Magazine*. (Both Grayhawk.)

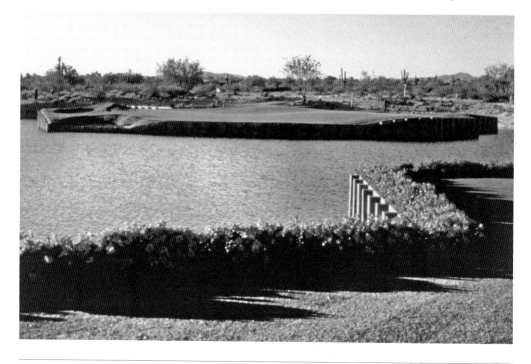

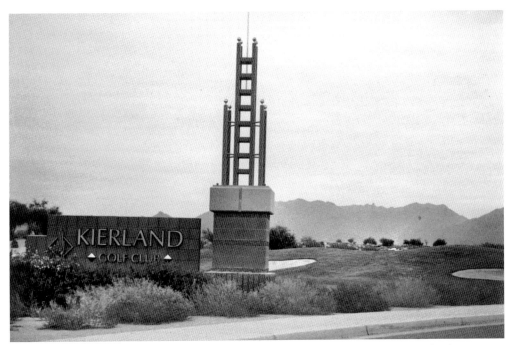

Kierland Golf Club is a 27-hole layout on the west side of Scottsdale Road and north of Greenway Parkway around which the community of Kierland, Kierland Commons, and the Westin Kierland Resort and Spa were built in the 1990s and early 21st century. The courses, designed by Scott Miller and opened in 1996, are Acadia, Ironwood, and Mesquite and include over 300 bunkers, lakes, and desert washes and many native plants and trees. Kierland was the maiden name of Kathryn "Kax" Herberger, whose husband and sons owned and developed the land on which Kierland was built. (Author's collection.)

World-renowned husband and wife golf instructors Mike and Sandy LaBauve estimated they have given over 30,000 golf lessons at Kierland Golf Club between 1996 and 2008. They operate the LaBauve Golf Academy at Kierland and provide instruction for golfers of all levels, from beginners to tour pros. Sandy credits Henry DeLozier for raising the bar for local golf instruction in the late 1980s at nearby Stonecreek Golf Course. Golf instruction and golf schools add to the tourism draw of golf in Scottsdale; nearly every resort and golf course has its own school and resident celebrity golf instructor. (Author's collection.)

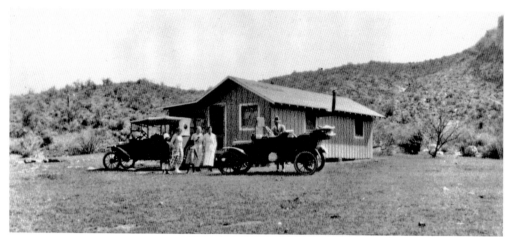

Scott Miller originally designed the 18-hole, private Country Club at DC Ranch Golf Course, which opened in 1997. It was the first of two 18-hole golf courses in the master-planned community of DC Ranch developed by DMB Associates. The courses and community take their names from the former 44,000-acre cattle ranch started in 1916 by Scottsdale pioneer and businessman E. O. Brown and partners. This photograph shows members of the Brown family at their Lower Ranch headquarters, the present site of the DC Ranch community. (Scottsdale Historical Society.)

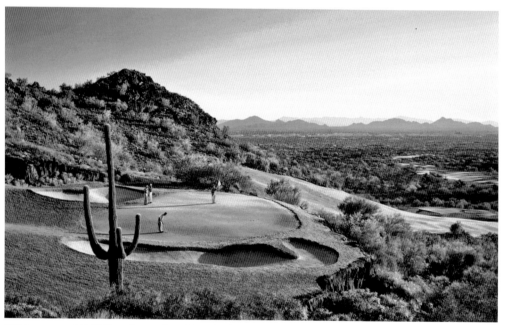

PGA star and DC Ranch resident Tom Lehman partnered with John Fought to redesign the Country Club at DC Ranch Golf Course in 2002. This image of the 13th hole shows a dramatic view of the Scottsdale and Phoenix Valley below; the DC Ranch layout is sited on the western slope of the McDowell Mountains, which were protected from development in perpetuity by the citizens of Scottsdale when they voted to fund land purchases for the McDowell Sonoran Preserve. (DC Ranch, Lonna Tucker.)

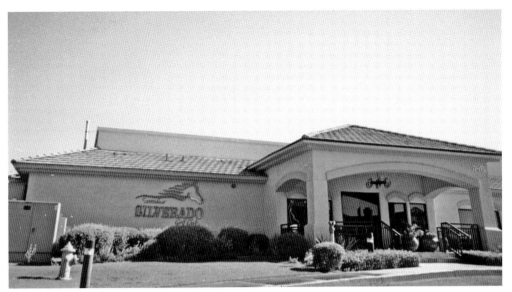

Years in the making, Scottsdale Silverado Golf Club is a public, daily-fee, 18-hole golf course that meanders through the Indian Bend Wash along Hayden Road and extends east toward Pima Road, south of Indian Bend Road. The course opened in 1999 as Scottsdale Links, closed the following year for renovations, and then reopened in 2001 as Silverado. The team of Gilmore and Graves designed the course. (Author's collection.)

What eventually became Silverado Golf Course was originally announced as the Inlet Golf Course, which was to be part of a hotel complex on the southeast corner of Indian Bend and Hayden Roads. When Scottsdale Links, forerunner of Silverado, opened in 1999, it was adjacent to the Holiday Inn Sunspree Resort, a wing of which can be seen on the left here. The Sunspree was closed in 2004 and razed to make way for golf course–view condominiums. (Author's collection.)

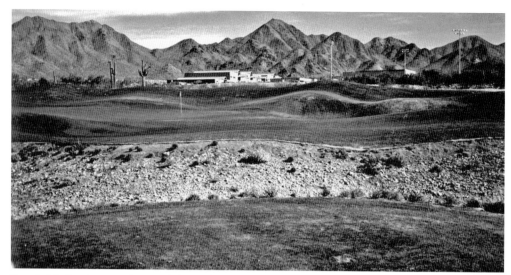

Randy Heckenkemper designed the 18-hole Sanctuary Golf Course at WestWorld, which opened in 1999 north of the Central Arizona Canal and east of Scottsdale's WestWorld equestrian and special event facility. It was the first golf course in Arizona to earn Audubon Signature Status for its eco-sensitivity that took advantage of the natural terrain and vegetation and its management of wildlife habitat, water quality, conservation, and waste reduction. This view of the fifth hole shows the McDowell Mountains as an impressive backdrop. (Author's collection.)

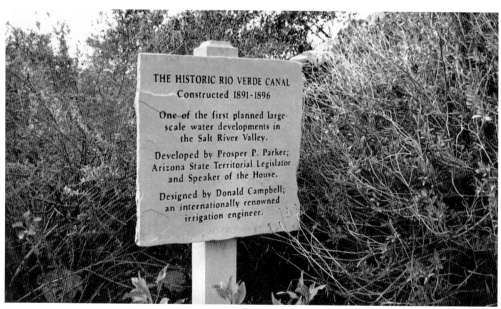

Golfers at Sanctuary Golf Course moving from the first green to the second tee will pass this sign paying tribute to the Rio Verde Canal, constructed between 1891 and 1896 to bring water from the Verde River to the Paradise Valley but never actually put into operation. A berm that goes between the two Sanctuary holes is all that is left of the old canal, which was often used by old-timers for picnics and target practice before development made both activities impractical. (Author's collection.)

Tom Weiskopf was selected to create a second private 18-hole course for the ultra-luxury community of Silverleaf within DC Ranch. The course, opened in 2002, is full of Weiskopf's signature risks and rewards for golfers of all levels; the mountain and valley views are awesome from every hole. A 50,000-square-foot clubhouse and spa set a new standard of luxury for country clubs in the Valley of the Sun, with many of its elements imported from Europe to give it an authentic rural Mediterranean look. (Author's collection.)

Caddies and forecaddies dressed in Masters-style white jumpsuits help golfers navigate Silverleaf's nuances. (Author's collection.)

Although Arizona State University in Tempe, just south of Scottsdale, had golf teams as early as the 1930s (in the photograph below), the university did not have a course of its own until 1988. Pete Dye designed the 18-hole collegiate ASU Karsten Golf Course across Scottsdale/Rural Road from Sun Devil Stadium and south of the Salt River bed. The daily-fee, public course is home to the Arizona State Sun Devils golf teams, which have produced such champions as Phil Mickelson, Billy Mayfair, Chez Reavie, Paul Casey, Heather Farr, Grace Park, Danielle Ammaccapane, and Brandie Burton. (Above, author's collection; below, ASU Archives.)

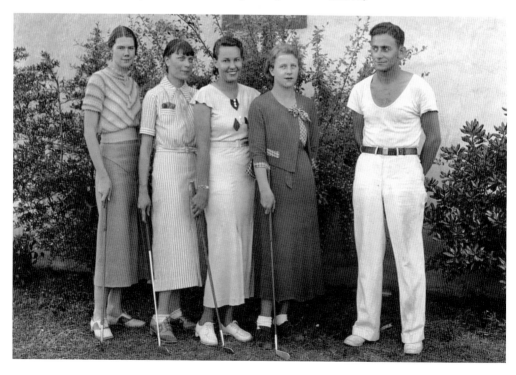

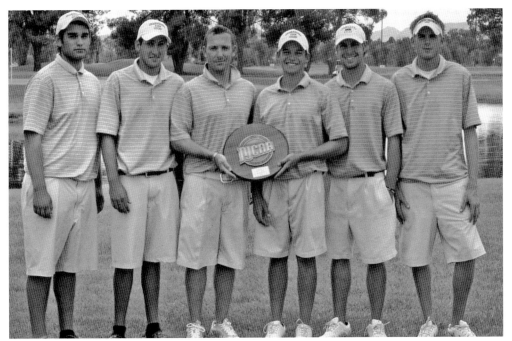

Throughout its 35-year history, the Scottsdale Community College Artichoke golf team has won 10 national championships. Shown from left to right are the 2007 National Junior College Athletic Association championship Artichoke golfers Rich Saferian, Jakob McKinley, Jon Levy (coach), Braxton Marquez, Kyle Kallan, and J. D. Guiney. (Jack Joseph.)

Construction for the Golf Club of Scottsdale began in 2003 and included excavation of a lake that would be used for irrigating the golf course. The lake is located north of the course's practice facility. Dick Bailey and Jay Morrish designed the 18-hole layout, which opened in December 2003 north of Dynamite Boulevard at East 112nd Street. (Dick Bailey and the Golf Club of Scottsdale.)

Members of the Golf Club of Scottsdale enjoyed their hacienda-style clubhouse when it opened in 2006. But the golf course was the real draw, offering views "unencumbered by homes as it winds its way through the unspoiled saguaro forests of North Scottsdale" according to a magazine advertisement for the course. Much of the Golf Course of Scottsdale is surrounded by preserve land. (Both the Golf Club of Scottsdale.)

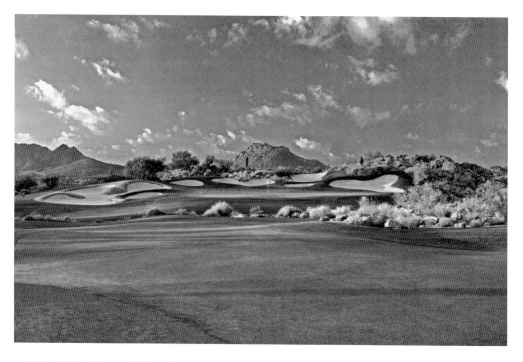

3

STARS AND SPECTATORS
FLOCK TO SCOTTSDALE
GOLF EVENTS

Tournaments and golf events have become a mainstay on the Scottsdale golf scene since the 1950s. The Phoenix Open played in Scottsdale at the Arizona Country Club in odd years between 1955 and 1973, rotating hosting duties with Phoenix Country Club. The tournament moved permanently to Scottsdale in 1987 when the TPC Scottsdale Stadium Course opened. Now named the FBR Open, it is the world's best-attended golf event, drawing more than 500,000 fans to the weeklong winter extravaganza.

The Tradition had a 12-year run at Desert Mountain, from 1989 to 2001, bringing the legends of senior golf. Grayhawk hosted the World Championship of Golf for several years in the 1990s. The inaugural Skins Games were played at Desert Highlands in 1983 and 1984.

Nearly every golf course in Scottsdale has hosted major tournaments and countless local tournaments for fun or charitable benefit. Celebrities often choose Scottsdale to hold an invitational or open tournament to benefit a favorite cause. The list of those who have sponsored tournaments in Scottsdale is a Who's Who of Hollywood, recording studios, and the sports world: Pat Boone, Alice Cooper, Harmon Killebrew, Randy Johnson, Curt Schilling, and many more.

The 1989 Spalding pitted stars of the PGA, LPGA, and Senior PGA at four Scottsdale courses; Mark Calcavecchia won. The Thunderbirds sponsor a Junior Golf Association tournament annually that attracts the stars of tomorrow. The Scottsdale Community College Artichokes, having won 10 national championships, have hosted Junior College Athletic Association tournaments in Scottsdale.

Rotary Clubs, the Scottsdale Area Chamber of Commerce, church groups, the Scottsdale Healthcare Foundation, school fund-raisers, the Make-A-Wish Foundation, and scores of other civic and charitable organizations sponsor annual tournaments. The Scottsdale 20/30 Club has sponsored an annual night golf tournament that raised funds for youth programs.

Beyond tournaments, golf show organizers find Scottsdale a great place to put on a showcase of equipment, travel, and instruction vendors. Golf shows have been held at the former Rawhide Western Theme Park and at WestWorld.

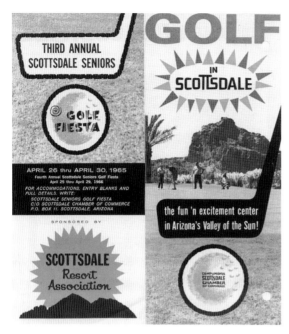

As early as the late 1950s, when the Scottsdale area had only a handful of golf courses, the Scottsdale Area Chamber of Commerce and local hotels and resorts began promoting Scottsdale as a great golf destination. One of the major annual promotions during the 1960s was the Scottsdale Seniors Golf Fiesta, held in late April. Male participants played at Scottsdale, Indian Bend, and Valley Country Clubs; enjoyed cocktail parties, dinners, and cookouts hosted by local resorts; and competed for prizes. Wives played golf at Mountain Shadows or pursued non-golf activities, like shopping. (Scottsdale Area Chamber of Commerce.)

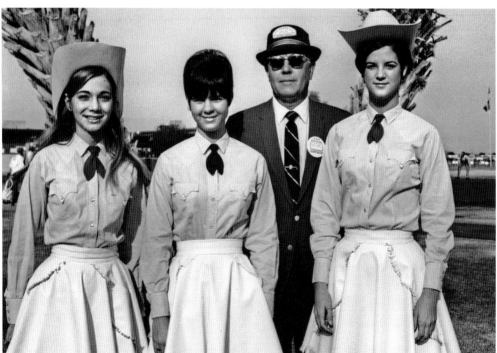

When the Scottsdale Area Chamber of Commerce began hosting or cosponsoring PGA and other golf tournaments, the chamber's Howdy Dudettes were there to welcome officials, golfers, and spectators to the events. The Dudettes, formed in the late 1950s, were Scottsdale High School coeds who served as the chamber's official welcoming committee and ambassadors at local and regional events of all kinds. (Scottsdale Historical Society.)

McCormick Ranch Golf Club, when it opened in the mid-1970s, hosted countless golf tournaments for local and national organizations and corporations. For several years in the 1970s, American Airlines held a Golf Classic at McCormick Ranch. Shown here from left to right are Jack Bratton, Jim Hart, Doug Kriedenier, and John E. Miller Jr. (John Miller family.)

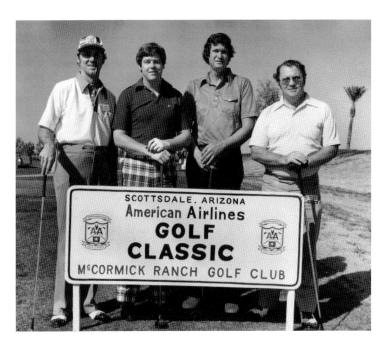

According to the front page of the October 5, 1962, issue of the *Arizonian*, Paradise Valley Country Club hosted the Scottsdale/Phoenix area's first female professional golf tournament in October 1962. The Phoenix Thunderbirds Ladies Open Golf Tournament featured 35 golf professionals vying for the $10,000 purse. Some 35 local amateurs were paired with the female golf pros in a Pro-Am as part of the tournament. The historic event followed the annual meeting of the Ladies Professional Golf Association (LPGA), which was held at the Hotel Valley Ho. (Mae Sue Talley, publisher, the *Arizonian*).

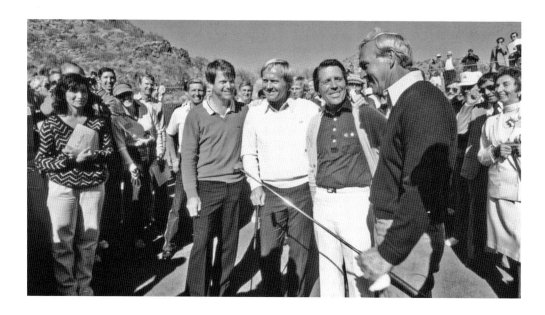

In a marketing coup for a new luxury golf development, Lyle Anderson and Jack Nicklaus brought the inaugural Skins Game to their innovative target desert Nicklaus-designed course at Desert Highlands in November 1983. Since it was nationally televised by NBC Sports and ESPN, television viewers got to see the best golfers of the day—from left to right above, Tom Watson, Jack Nicklaus, Gary Player, and Arnold Palmer—compete for big money on a new course no one had ever played. Gary Player won the 1983 event and Jack Nicklaus won the 1984 event, but the clear winner was the Desert Highlands Golf Course and its lot sales. (Both Desert Highlands Golf Club.)

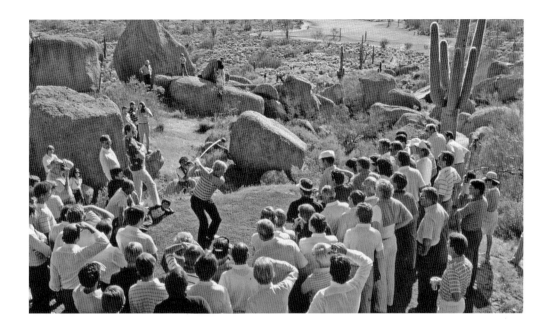

The inaugural Skins Game in 1983 was a concept developed by Don Ohlmeyer, Ohlmeyer Communications, and Trans World International. Each hole was a tournament in itself, pitting the famous foursome against each other and the course, just as golfers everywhere often did on Saturday mornings—only this time, the stakes were a bit higher. The photograph above shows Jack Nicklaus at the tee; the photograph below recaps the Skins wins during the 1983 game. Although the Skins Game moved on after its first two years at Desert Highlands, the games and Desert Highlands each celebrated their 25th anniversaries of success in 2008. (Both Desert Highlands Golf Club.)

DESERT HIGHLANDS SCOTTSDALE		
HOLE 1 2 3 4 5 6 7 8 9 10 11 12 13 14 15 16 17 18		
PAR 4 5 4 3 4 4 3 4 5 4 5 3 4 4 3 3 5 5		
PLAYER	**HOLES WON**	**MONEY**
J NICKLAUS	3 18	40 000
A PALMER	6 7 12	140 000
G PLAYER	2 4 17	170 000
T WATSON	1	10 000

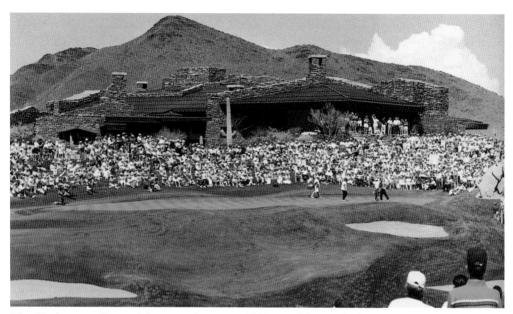

The Tradition at Desert Mountain began in 1989 to celebrate the history of golf and to honor the best players in the world. It became one of the four majors on the Senior (now Champions) PGA Tour. It also showcased the new Jack Nicklaus Signature golf courses at Desert Mountain, developed by Lyle Anderson. This photograph shows the gallery on the 18th hole of the Renegade Course in April 1991. (The Lyle Anderson Company.)

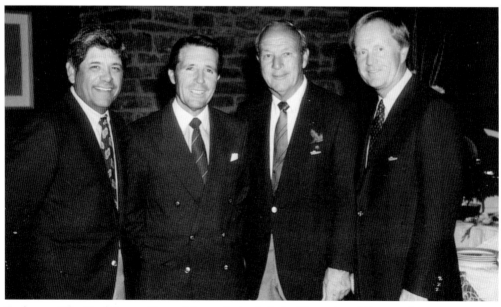

Each year, The Tradition at Desert Mountain included a Champions Dinner, where tournament participants could relax and enjoy the pre-competition camaraderie. Shown here at the inaugural 1989 Tradition Champions Dinner are, from left to right, Lee Trevino, Gary Player, Arnold Palmer, and Jack Nicklaus. (The Lyle Anderson Company.)

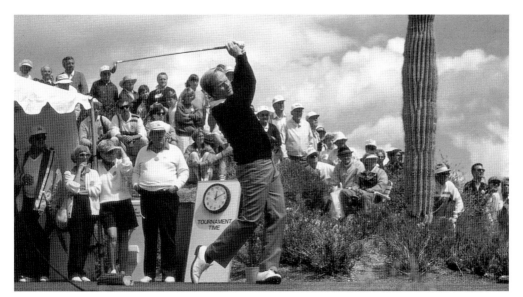

Don Beis won the 1989 Tradition; Desert Mountain Golf Courses designer Jack Nicklaus won in 1990 and 1991 and twice more before the tournament moved to Superstition Mountain, another Lyle Anderson–Jack Nicklaus development, in 2002. Throughout its 12-year run at Desert Mountain, The Tradition raised over $1.5 million for local charities. (The Lyle Anderson Company.)

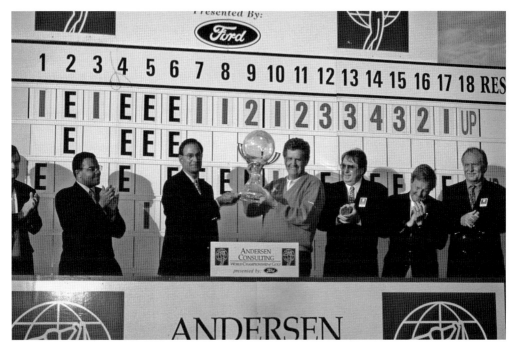

Andersen Consulting World Championship of Golf held its annual year-end tournament at Grayhawk Golf Courses from the year the Talon Course opened in 1994 through the 1990s. Here the 1998 winner, Colin Montgomerie, accepts his trophy. (The Thunderbirds.)

Grayhawk Golf Course hosted the 2005 Tommy Bahama Challenge, which showcased the world's top young golfers. Four U.S. players competed in individual 18-hole stroke-play matches against their international counterparts. Played on November 9, 2004, it aired on CBS Sports on January 1, 2005. The American Team is shown here. (Grayhawk.)

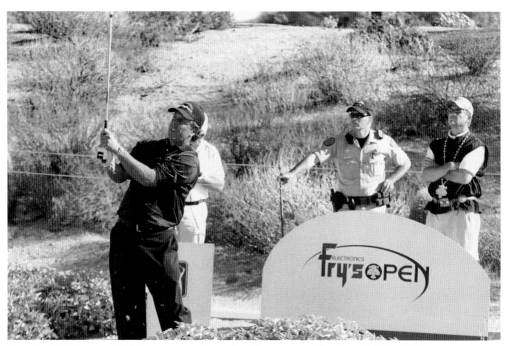

Grayhawk's Raptor Golf Course was selected as the location for the 2007 Fry's Electronics Open, an October 15–21 stop on the PGA Tour's Fall Series. The Thunderbirds served as host for the tournament, which brought in a large contingent of tour players. Shown here is local favorite Phil Mickelson, who starred at ASU and is the namesake of Phil's Grill at the Grayhawk clubhouse. Mike Weir won the tournament. (Grayhawk.)

The granddaddy of all golf tournaments in the Scottsdale-Phoenix area—and the entire PGA Tour—is the FBR Open, formerly known as the Phoenix Open. It began in 1932 as the Arizona Open and was played at the Phoenix Country Club with R. D. Roper as tourney chair and William Hartranft as host club president. Ralph Guldahl won the $600 purse; Gene Sarazan came in fifth to win $100. This photograph shows Ben Hogan with his hand in a box held by Bob Goldwater. (The Thunderbirds.)

After four consecutive tournaments (1932–1935)—with the 1934 Pro-Am won by Ky Laffoon and Barry Goldwater—the Depression had an impact, and no tournament was held again until 1939. Thanks to a new sport booster group affiliated with the Phoenix Chamber of Commerce, the Thunderbirds, the tournament was revitalized with champion Bob Goldwater as its chair. This early photograph shows Ben Hogan (left) and Herman Barron (right). (The Thunderbirds.)

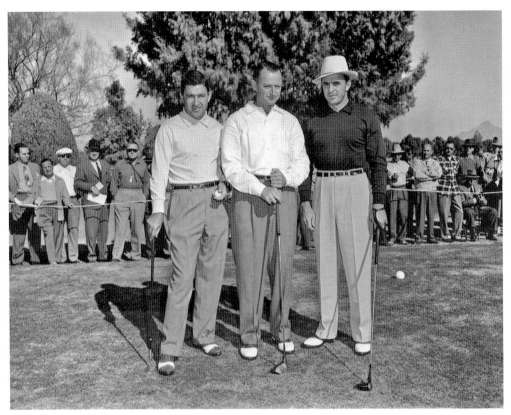

In the beginning, when purses were puny by today's standards, members of the Thunderbirds often put Phoenix Open participants up in their homes and hosted dinners that players could otherwise ill afford. Bob Goldwater served as the tournament chair every year from 1939 to 1951. He is shown here in the center, with Sam Snead on the right. (The Thunderbirds.)

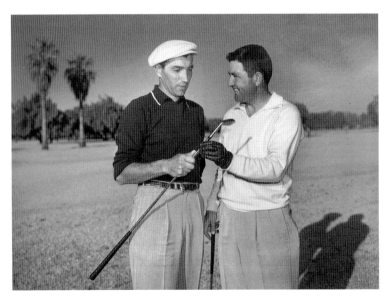

Ed Furgol (left) won the 1954 Phoenix Open at the Phoenix Country Club, receiving an increased purse of $15,000. Future governor of Arizona Paul Fannin was the tournament chair. (The Thunderbirds.)

Big Chief of the Thunderbirds John E. "Brick" Miller (left) awarded Jimmy Demaret (right) his purse and Thunderbird pendant at the 1950 Phoenix Open. In 1976, Brick's son John E. Miller Jr., a Scottsdale businessman and civic leader, ran the tournament and became Big Chief the following year. (John Miller family.)

After nearly losing his life in a car-bus accident en route to his Fort Worth home after the 1949 Phoenix Open, Ben Hogan courageously rehabilitated his many broken bones to play in the 1950 golf season. The 1950 Phoenix Open was referred to as the Ben Hogan Open in his honor. He is shown here at right, with Jimmy Demaret in the center and Thunderbird Charles H. Sporleder at left. (The Thunderbirds.)

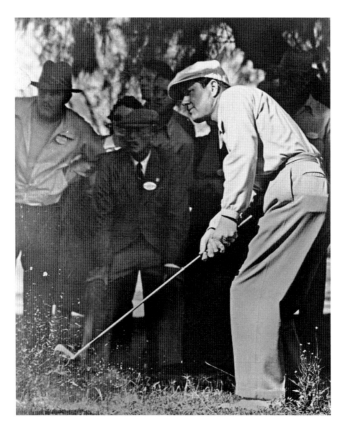

Byron Nelson won the 1939 Phoenix Open, earning the first prize of $700. Ben Hogan finished second, winning $450, and Phoenix-area golfer Johnny Bulla tied for fifth, earning $175. Nelson won the tournament again in 1945. (The Thunderbirds.)

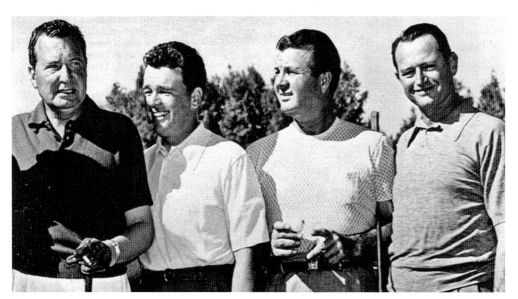

One of the perennial participants in the celebrity Pro-Am at the Phoenix Open was entertainer Phil Harris, shown here at far left with his foursome for the 1955 event, which included, from left to right, Jackie Burke Jr., Jimmy Demaret, and Bob Goldwater. (The Thunderbirds.)

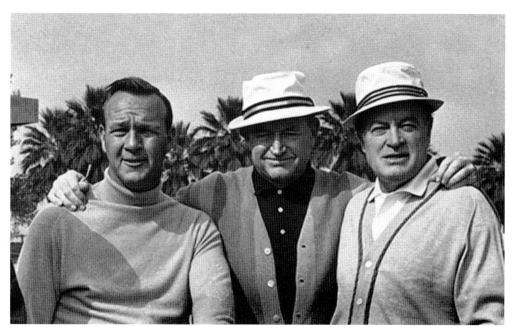

Arnold Palmer made his debut as a professional golfer at the 1955 Phoenix Open, which was played for the first time at the Arizona Country Club. The Thunderbirds began an every-other-year rotation of the tournament between the Phoenix and Arizona Country Clubs, putting the spotlight on Scottsdale in the odd years from 1955 through 1973. Here Palmer is at left with Bob Goldwater and Bob Hope during a 1960s Phoenix Open. (The Thunderbirds.)

After bringing out thousands of "Arnie's Army" to watch him participate in the annual tournament, the Thunderbirds made Arnold Palmer an honorary Thunderbird and elected him a charter member of the Phoenix Thunderbirds Golf Hall of Fame (the other charter inductee was Gene Littler). Palmer won the tournament three times—1961, 1962, and 1963, all at Arizona Country Club. His Phoenix Open winner's purse was $5,300 in both 1962 and 1963. He is shown here second from right; Ken Venturi, who won the 1958 Phoenix Open, is holding the microphone. (The Thunderbirds.)

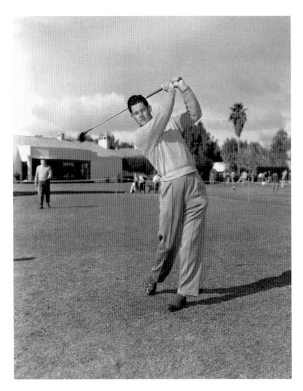

Dentist Carey Middlecoff won the 1956 Phoenix Open. Two years earlier, he had tied with Ed Furgol but lost in a playoff 19th hole. As defending champion in 1957 at the Arizona Country Club–hosted Phoenix Open, he tied for second with Mike Souchak, each earning a second-place $1,350. (The Thunderbirds.)

Billy Casper won the 1957 Phoenix Open at Arizona Country Club, besting Carey Middlecoff and Mike Souchak. He is shown here second from the left with Thunderbird and U.S. senator for Arizona Barry Goldwater second from right. (The Thunderbirds.)

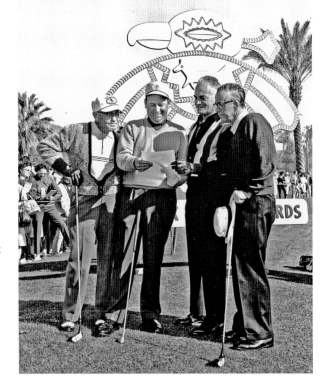

John E. Miller Jr. (left), 1976 tournament chair and 1977 Big Chief of the Thunderbirds, congratulates 1977 Phoenix Open winner Jerry Pate (right). By this time, the purse for the winner was up to $40,000. Miller, a second-generation Thunderbird Big Chief, missed awarding another John Miller the top honors by one year—Johnny Miller won the Phoenix Open in 1974 and 1975. (John Miller family.)

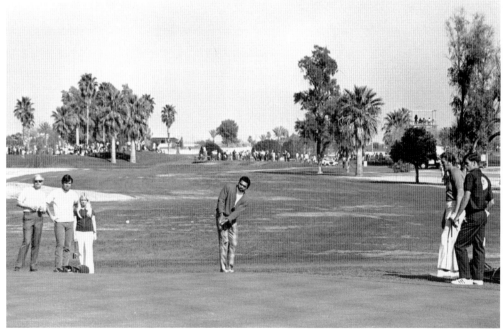

Sports celebrities were always a crowd favorite during the Phoenix Open Pro-Am, particularly before the metro Phoenix area had major-league teams of its own. Here Reggie Jackson chips on the green during a 1970s Phoenix Open Pro-Am. (The Thunderbirds.)

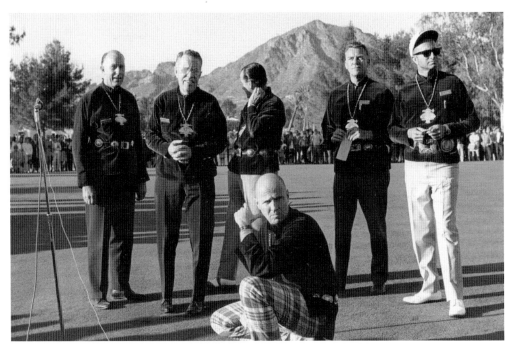

The Thunderbirds, organized in 1937, have provided many leadership opportunities for members while serving their community and raising millions for local charities. Among their ranks have been U.S. senators and Arizona governors, business leaders, and all-around good citizens. Shown here with fellow Thunderbirds at the Arizona Country Club are Paul Fannin (left), who served as a U.S. senator (1965–1977) and governor of Arizona (1957–1965), and Jack Williams (second from left), who served as mayor of Phoenix (1956–1960) and governor of Arizona (1967–1975). (The Thunderbirds.)

Television star and excellent golfer Lawrence Welk was a frequent participant in Phoenix Open Pro-Ams. He is shown here (left) at the 1974 Phoenix Open with, from left to right, an unidentified man, Billy Casper, and Scottsdale businessman and former undersecretary of the interior Dick Searles. (Richard Searles family.)

Johnny Miller, winner of the 1974 and 1975 Phoenix Opens, was also selected PGA Player of the Year in 1974. Miller also won the Tucson Open in 1975. On his final round for the win in 1975, he shot an incredible 64 at the Phoenix Country Club and came in 24 under par for the four days, setting a new tournament record. The following year, he won the 1976 British Open. (The Thunderbirds.)

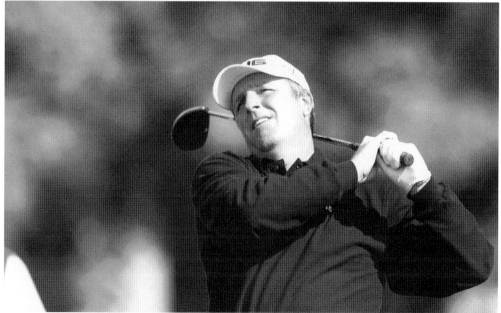

The Phoenix Open moved to the new TPC Scottsdale Stadium Course in January 1987. Paul Azinger won the tournament, and local favorite Mark Calcavecchia tied for third place. "Calc," shown here, won the 1989 Phoenix Open and again in 1992 and 2001. During the first round of the 1992 Open, Calc carded an ace on the fourth hole. (The Thunderbirds.)

Vijay Singh won the 1995 Phoenix Open at the TPC Scottsdale in a playoff on one extra hole. Singh's earnings were $234,000 of the total $1.3-million purse. Singh had a repeat victory in the 2003 event, earning $720,000. (The Thunderbirds.)

Scottsdale resident and fan favorite Tom Lehman won the 2000 Phoenix Open, which had a take-home pay of $576,000. Lehman played on the 1995, 1997, and 1999 Ryder Cup teams and is now balancing his playing career with one in course design. (The Thunderbirds.)

Relatively unknown when he won his first FBR Open in 2006, J. B. Holmes came back to win again in 2008 at the TPC Scottsdale Stadium Golf Course. (The Thunderbirds.)

An Australian phenom who moved to Scottsdale, Aaron Baddeley won the 2007 FBR Open and became the first winner in the event's 75-year history to earn over $1 million, taking home prize money of $1,080,000. (The Thunderbirds.)

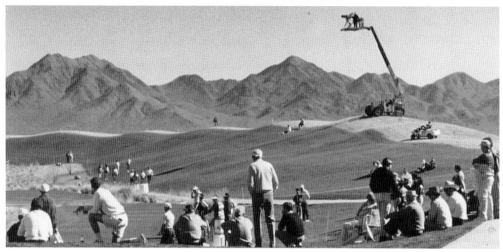

Not only did the hosting Thunderbirds gain a much larger venue for their annual tournament when the Phoenix Open moved to the new TPC Scottsdale in January 1987, they also had a site that was pre-wired for television broadcasting. Underground television cables were installed during construction of the course to make it easier to set up for the worldwide telecasts. During the first Open at TPC Scottsdale, 257,000 attended in person, while millions more watched on television. (*Scottsdale Airpark News.*)

Staging a successful Phoenix (now FBR) Open takes the almost full-time attention of members of The Thunderbirds, who start planning the next tournament the day the current one ends. They are augmented by thousands of volunteers who serve in a myriad of jobs. One of The Thunderbird traditions during the tournament is "crazy pants day," exhibited by this group. (*Scottsdale Airpark News.*)

Despite the large increase in the number of fans that could attend an open when it moved to TPC Scottsdale, players still made themselves available for autographs. Here Fuzzy Zoeller signs a program during a late-1980s event. (*Scottsdale Airpark News.*)

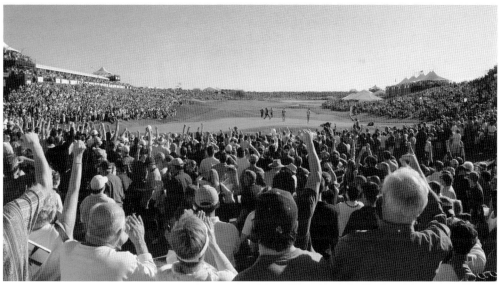

Course co-designer Tom Weiskopf knew the 18th "home hole" would give golfers a challenge when they played the TPC Stadium Course, but even he couldn't have imagined the tens of thousands who would surround the hole during the final round. Corporate tents also line both sides of the 18th fairway. (The Thunderbirds.)

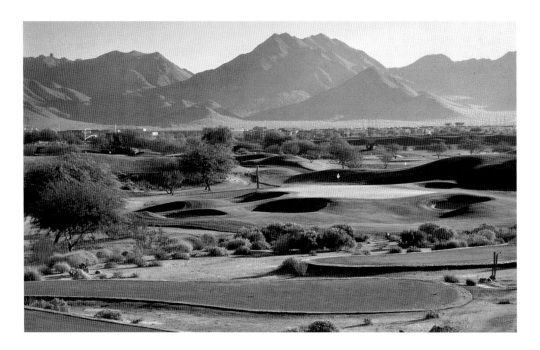

Fifty-one weeks a year, the par-three 16th hole has a beautiful view of the McDowell Mountains. The 16th hole, however, produces a phenomenon unlike any other golf tournament during the FBR Open and is known as the best party in golf. Youthful fans show their approval or disapproval of every shot. Players walk through a tunnel under the skyboxes from the 15th green and enter an arena of surreal proportions. The crowd chants, "Get it in the hole!" (Both the FBR Open.)

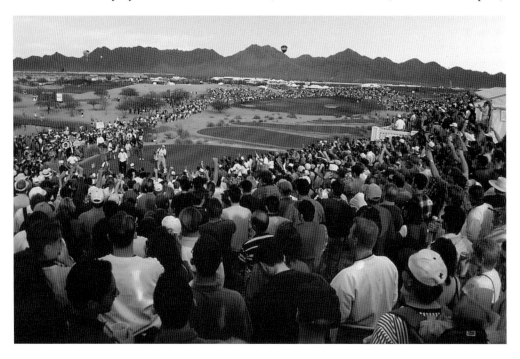

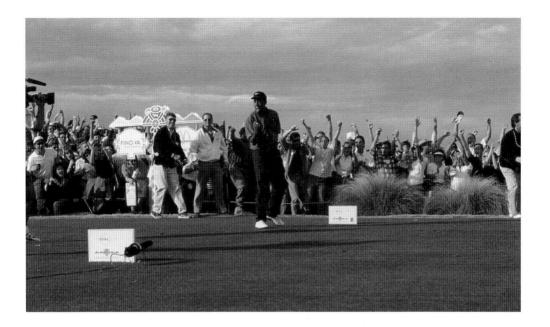

Tiger Woods ratchetted up the excitement at the infamous 16th hole when he scored a hole-in-one during the 1997 Phoenix Open. Each year, the number of skyboxes on the 16th hole has increased, creating an almost horseshoe effect around the fairway and green. (Both the FBR Open.)

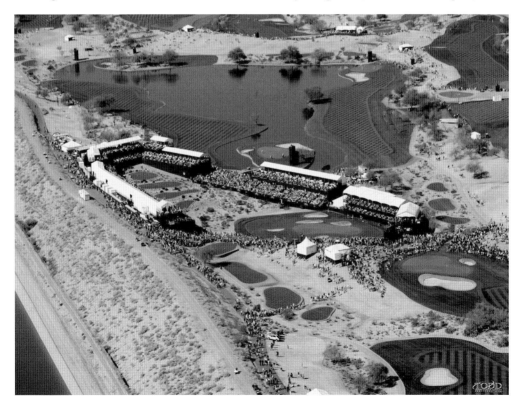

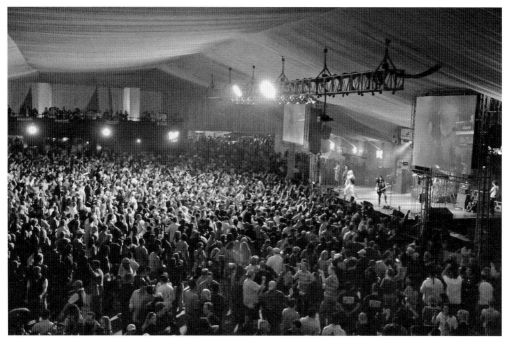

When the last foursome comes in from a round at the FBR Open, the real partying begins. "The Birds Nest" began as a small party tent at the Phoenix Country Club and is now dubbed as a supersize party tent. It also contributes to the overall funds raised for local charities during tournament week. (The FBR Open.)

The LPGA hosts an annual tournament in the metro Phoenix area every spring, bringing female golf greats to Scottsdale courses—for last-minute practicing or to participate in events that benefit their favorite causes. Shown here are Betsy King (standing second row) and, seated from left to right, Juli Inkster, Kathryn Hull, Regan Riley, Angela Stanford, and Pat Hurst. They gathered in March 2008 at Scottsdale's Desert Highlands Golf Course to conduct a clinic that benefitted Golf Fore Africa, a member charity initiative of the LPGA. (Author's collection.)

4

GOLF IS A GAME

OF PERSONALITIES

With a year-round climate conducive to golf, dozens of top-ranked golf courses, the best-attended PGA golf tournament in the world, and an array of golf-support businesses here, who wouldn't want to play golf in Scottsdale?

Celebrities of all types—from the sports world to movie stars, singers, entertainers, comedians, writers, politicians, and business celebrities—all seem to end up on Scottsdale links, and the fans pour out to watch them. Bob Hope, Bing Crosby, Dean Martin, Bill Murray, and George Lopez have all been gallery favorites.

PGA and LPGA stars with local ties have also generated cheers from the crowds: Phil Mickelson, Tom Lehman, Billy Mayfair, Howard Twitty, Tom Purtzer, Gary McCord, Mark Calcavecchia, Kirk Triplett, Jan Stephenson, Betsy King, Grace Park, and more.

Some of the best golf course designers and architects in the business have worked from Scottsdale: Johnny Bulla, Gray Madison, Jack and Art Snyder, Red Lawrence, Scott Miller, Tom Weiskopf, Hale Irwin, Gary Panks, Milt Coggins, Tom Lehman, Phil Mickelson, Dick Bailey, and more.

Big-name golf schools and instructors have operated here, including Jim Flick, Gary McCord, John Jacobs, Scott Sacket, Mike and Sandy LaBauve, Bill Forrest, Ruth Jessen, Sandy Futch, Henry DeLozier, and many more.

Those who run Scottsdale and area golf organizations are unsung heroes, like Ed Gowan, longtime executive director of the Arizona Golf Association, and everyone who has ever been a chair of the Phoenix/FBR Open.

Vice president of the United States Thomas Marshall and his wife, Lois, were frequent guests at the Ingleside Inn. They came to Scottsdale every winter to visit Lois's parents, William and Elizabeth Kimsey. This photograph shows Marshall in the center holding a golf ball at the Ingleside Golf Course sometime between 1913 and 1916. He served as Pres. Woodrow Wilson's vice president from 1913 to 1921. The Marshalls built a home on Indian School Road just west of Scottsdale Road, where they lived after he left office. (Dorothy Robinson Collection, Arizona Collection, ASU Libraries.)

Another Indianan who served as vice president of the United States and played golf in Scottsdale is Dan Quayle, vice president to George Bush Sr. 1988–1992. Shown here at left with ASU golf star and future PGA Tour champion Phil Mickelson, Quayle is a frequent celebrity player at charity tournaments throughout the Greater Scottsdale and Phoenix area. (Quayle family.)

Pres. George Bush Sr. is an avid golfer and counts several PGA stars as personal friends. He attended the 2007 FBR Open at the TPC Scottsdale but didn't play in the Pro-Am because of recent hip surgery. Instead, he joined the gallery and enjoyed the action on the course. (The FBR Open.)

Mayor Mary Manross may be one of the few mayors of Scottsdale who has played golf. Although she doesn't find enough time to play regularly, she has a great swing that her mother, an excellent golfer, taught her. Here then-councilwoman Manross participates in a tee-off to celebrate the groundbreaking for the Apache Course at Desert Mountain in September 1994. (Manross family.)

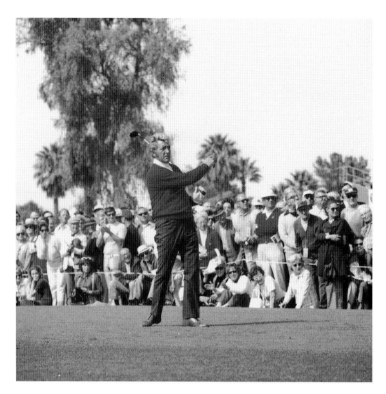

Singer and actor Dean Martin was a popular guest at the Phoenix Open Pro-Ams during the 1960s and 1970s. He, Bing Crosby, Bob Hope, and others could always entertain the gallery with their on-course antics, but they were very good golfers, too. (Robert Markow and The Thunderbirds.)

Baltimore Orioles manager Paul Richards (left) played at Paradise Valley Country Club whenever he was in town during the 1950s. He ran into some of his fellow PVCC golfers at Scottsdale's Pink Pony one day and promised them that if they built a stadium, he would bring the O's to Scottsdale for spring training. They did, and he did, starting in the 1956 season. He is shown here with golf partner and friend Mel Decker, twice president of PVCC and one of the club's golf champions. (Mel Decker.)

GOLF IS A GAME OF PERSONALITIES

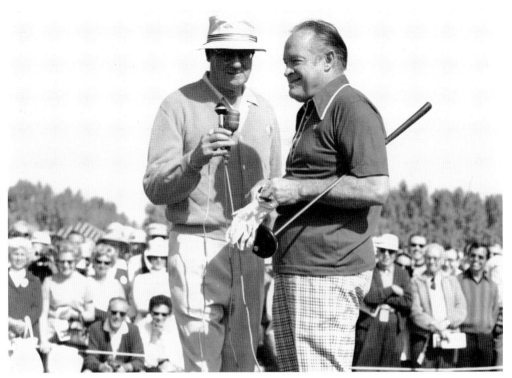

Developer and former owner of the New York Yankees Del Webb (left) and Bob Hope (right) were friends and regular participants in the Phoenix Open Pro-Am. In his book *Confessions of a Hooker: My Lifelong Love Affair with Golf*, which Hope wrote with Scottsdale resident Dwayne Netland, Hope praised the Arizona Country Club, stating, "I loved that golf course because whenever I shanked, the ball always still seemed to be in play." (Robert Markow and the Thunderbirds.)

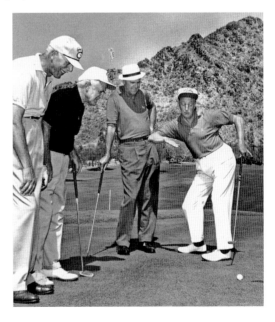

With a well-connected membership, one never knew whom they might see on the links at the Paradise Valley Country Club. Here actor Ray Bolger entertains his foursome, which includes early PVCC member, club golf champion, and twice club president Mel Decker, second from right; the other two men are unidentified. (Mel Decker.)

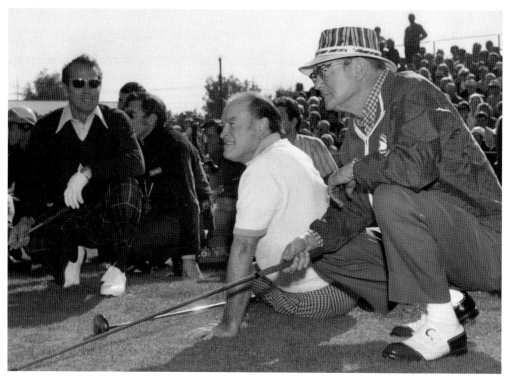

Scottsdale car dealer Lou Grubb (left) was one of many prominent valley businessmen who relished the opportunity to play in the Phoenix Open Pro-Am, often paired with celebrities like Bob Hope (center) and other local business leaders, such as developer Del Webb (right). (The Thunderbirds.)

Bing Crosby, a very accomplished golfer with a tournament, or "clambake," of his own in Pebble Beach, came to Scottsdale and Phoenix often in the 1950s and 1960s to play golf and hunt doves. He is seen here (right) with owner of the Hotel Valley Ho Robert "Bobby" Foehl. (Hotel Valley Ho.)

GOLF IS A GAME OF PERSONALITIES

Singer Glen Campbell, a Scottsdale-area resident for many years and an enthusiastic golfer, was a regular player in the Phoenix Open Pro-Ams and in other charity tournaments around town. He is shown here attending the inaugural Phoenix Open at the TPC Scottsdale in 1987. (*Scottsdale Airpark News.*)

When the Phoenix Open moved to the TPC Scottsdale in 1987, so did Bob Hope, who continued to play in the Pro-Am and sign autographs for his many fans. (*Scottsdale Airpark News.*)

Scottsdale business leaders, like John E. Miller, became local celebrities through the visibility that running the Phoenix Open gave them. Miller and other Scottsdale-based Thunderbirds, like Len Huck and Phil Edlund, became community leaders who also helped enhance the economic impact and enjoyment of golf in Scottsdale. (John Miller family.)

Scottsdale car dealer Ray Korte (second from left) was the tournament chair of the Phoenix Open in 1960 and was again involved in a leadership role in 1962 when he was president of the hosting Arizona Country Club. He is shown here with British golf star Tony Jacklin (left); the other two golfers are unidentified. (Korte family.)

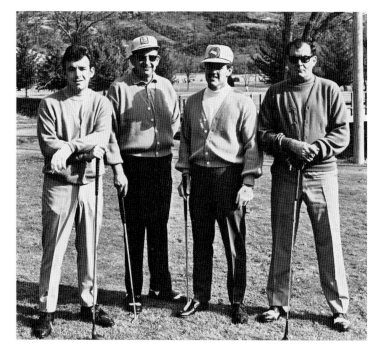

GOLF IS A GAME OF PERSONALITIES

Johnny Bulla was big on the golf and business scene throughout the Scottsdale and Phoenix area in the 1950s, 1960s, and 1970s. He played in several Phoenix Opens as a ranked PGA tour player before turning to golf course design. He designed the Century Country Club and redesigned the Arizona Country Club. He is shown here (right) in the February 21, 1958, edition of the *Arizonian* with William Barclay as they plan the Greenbriar Country Club in Phoenix. (Mae Sue Talley, publisher, the *Arizonian*.)

Gray Madison (left) was both a golf champion and an astute businessman who owned car dealerships in Scottsdale. He helped plan the Paradise Valley Country Club Golf Course and convinced his fellow businessmen to become charter members of the new club in 1953. He is shown here with Bing Crosby as they leave the Camelback Inn to play in the Phoenix Open Pro-Am. The caption in the *Arizonian* stated a gallery of "more than 1,000 persons followed the crooner around the fairways." (Mae Sue Talley, publisher, the *Arizonian*.)

Musician Hoagy Carmichael (center) stands with Mountain Shadows Resort general manager Don B. Burger (left) and Mountain Shadows golf pro Al Demaret in this February 1962 photograph from the *Arizonian*. Carmichael and Demaret, paired with entertainer Phil Harris and baseball great Dizzy Dean, played in an exhibition match at Mountain Shadows Golf Course before playing in the Phoenix Open Pro-Am. (Mae Sue Talley, publisher, the *Arizonian*.)

Ken Venturi, who won the 1958 Phoenix Open, was often seen in Scottsdale, either in person or in advertisements for Hanny's, a popular clothing store on Main Street in downtown Scottsdale. (Mae Sue Talley, publisher, the *Arizonian*.)

The Ken Venturi
Golf Cardigan
by Jantzen

Here's Ken Venturi modeling the handsome cable-trimmed cardigan with bell sleeves that's making news on the fairways. It's a happy blending of springy alpaca and soft wool that's mothproofed for life. Your choice of seven colors, 18.95. Team it up with the Ken Venturi Club shirt in fine cotton for a perfect twosome, 6.00.

HANNY'S
Scottsdale
25 WEST MAIN STREET

During his 16 years as mayor of Scottsdale, non-golfer Herb Drinkwater did more than just about anyone to promote golf in his beloved city. He aggressively sought the location of two Tournament Players Courses in Scottsdale, helped bring the Phoenix Open to the new TPC Course, helped ensure new golf communities were developed within the city's guidelines, and welcomed countless visiting golfers and tournaments to town. He was made an honorary Thunderbird and inducted into the Phoenix/FBR Open Hall of Fame in 1998. (City of Scottsdale.)

Celebrities and tour players put the sizzle in Scottsdale golf, but it is the everyday golfer and his or her friends and business associates who perhaps enjoy Scottsdale's golf courses and events the most. Typical of Scottsdale golfers enjoying a 1980s company golf outing at Gainey Ranch Golf Club are Henry and Horne directors Mark Eberle (left) and Dean Young. (Henry and Horne, LLP.)

Bob Goldwater was considered the father of the Phoenix/FBR Open; he convinced the newly formed Thunderbird organization in the late 1930s that a tournament would be a good promotional vehicle for the Valley of the Sun. Goldwater, his brother Barry, and sister Carolyn learned to play golf at an early age from their mother, Josephine, who was a state women's champion when golf courses had dirt fairways and oiled sand greens. He continued to promote golf, the FBR Open, and his home state of Arizona until his death at age 91 in November 2006. (The Thunderbirds.)

5

GOLF INDUSTRY
CONTRIBUTES TO
SPORT COMMUNITY

With dozens of golf courses, favorable year-round golf weather, a thriving tourism industry, and upscale residential communities that include golf, it is no wonder Scottsdale is home to a myriad of golf-oriented businesses. Some golf-related businesses started here and then moved to other valley communities. For example, Tom Dooley founded the Antigua Group, a golf and sports apparel manufacturing company, in Scottsdale in 1976 and later moved it to the West Valley. Others began here and expanded to other cities. For example, Roger Maxwell started In Celebration of Golf in Scottsdale and has expanded to Las Vegas; stores are also in several airports throughout the United States.

The Scottsdale Airpark is home to several custom golf club companies and club fitters, such as Hot Stix Golf, which calls itself a pioneer in the science of feel. Computerized equipment helps golfers of all skill levels find the perfect fit of game to club.

Scottsdale has always had the national golf retail chains—Nevada Bob's, Golfsmith, Pro Golf Discount, PGA Superstore, and others. But it is fortunate to have had some of the best independents in the business. Emil Weser was the dean of the independent golf shop owners for over 35 years; he retired in 2008. Van Bocchini, founder of Van's Golf Pro Shops, came to Scottsdale in 1963 and built a statewide chain of family-owned golf shops that offered customers good value. Hornacek's is another locally run independent, and there are others.

Perhaps the most successful story of Scottsdale golf businesses has been the development of luxury golf communities. Among the top developers are Lyle Anderson and Jerry Nelson, who combined vision and dedication with environmental sensitivity to create world-renowned residential communities in the Pinnacle Peak area and far north Scottsdale. Greg Tryhus is the man behind Grayhawk and Mirabel; DMB Associates developed DC Ranch and Silverleaf.

Scottsdale Rush Hour Traffic

The Scottsdale Area Chamber of Commerce and the Scottsdale Convention and Visitors Bureau have considered golf a key to economic vitality. Scottsdale CVB president and CEO Rachel Sacco, with over 20 years of perspective promoting Scottsdale, said in 2008, "Scottsdale has evolved into one of the world's finest golf destinations offering championship golf courses, as well as a variety of amenities that appeal to avid golfers. Golf is a competitive advantage for Scottsdale as we offer not only a huge quantity of courses, but also great quality unmatched by any other destination. In Scottsdale, golf continues to be one of the top 10 activities enjoyed by our visitors." She's not kidding; the direct economic impact of golf in Scottsdale was nearly $50 million in 2008. The FBR Open pumps $180 million into Arizona's economy. The Scottsdale CVB advertises and hosts numerous familiarization visits for travel agents, meeting planners, and travel and golf media. (Left, Scottsdale Convention and Visitors Bureau; below, Scottsdale Historical Society.)

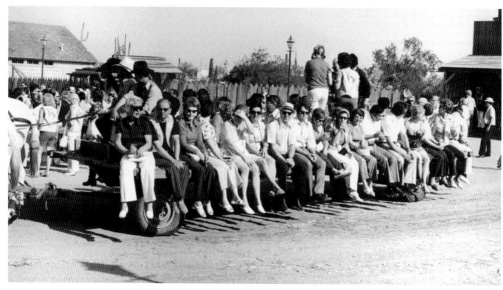

Golf businesses in Scottsdale have come in all shapes, sizes, and themes. The 19th Hole was a golf-themed barbeque restaurant "way out" on the southwest corner of Shea Boulevard and Scottsdale Road in the 1950s. Now nearly every golf course has a restaurant, grill, and/or snack bar. (Scottsdale Historical Society.)

Karsten Solheim displays his Ping Anser putter in this 1960s photograph. In 1966, the Solheim home was near Thirty-second Street and Shea Boulevard in Phoenix. Karsten, however, acquired a post office box in Scottsdale to use as his business address. This is how the Anser putters produced in Karsten's garage became known as "Scottsdale Ansers," since that is where they were mailed from. The putters are now a highly sought collectible, doing a brisk business on Internet auction sites. From his garage business, Solheim built Ping into one of the largest golf club manufacturing businesses in the world, based in Phoenix. (Karsten Manufacturing Corporation.)

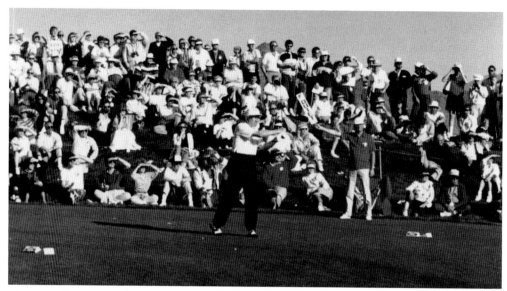

Karsten Solheim not only invented the Ping putter and perfected an extensive line of golf equipment, but he was a pretty good player, too. He is seen here playing in a 1980s Pro-Am at the Phoenix Open at TPC Scottsdale. Solheim passed away in 2000. (*Scottsdale Airpark News*.)

With its headquarters and manufacturing plant in the metro Phoenix area, Ping has been a familiar name at many golf events and sponsoring tournaments and participated in equipment demo days at golf courses and clubs. Ping founder Karsten Solheim helped boost the international esteem of women's golf by sponsoring the Solheim Cup, a biennial match that mirrors the men's Ryder Cup competition. This photograph shows Doug Simonsen (far left), Jerry Nelson (third from right), and others at Pinnacle Peak Country Club publicizing the club's hosting of the 1978 Ping Arizona Open. (Pinnacle Peak Country Club.)

Troon Golf, founded in 1990 by Dana Garmany with his first property, Troon North Golf Club in Scottsdale, has grown to manage 14 upscale golf clubs in Arizona and over 200 worldwide in 2008. The Scottsdale-based company is the world's leading luxury-brand golf management, development, and marketing company. Focusing solely on high-end luxury golf properties and developments, Troon Golf has earned a reputation for offering golfers the best experience at the best courses in the world. (Author's collection.)

Van Bocchini, founder of Van's Golf Pro Shops, came to Scottsdale in 1963. He built the Cypress (formerly Evergreen) Golf Course and started Van's Pro Shop, a popular golf retail chain based in Scottsdale. Founder Van died in 2000, but 11 stores throughout the state that bear his name continue to operate in a golf equipment–hungry environment like Arizona. (Author's collection.)

Formerly a director of golf at Camelback Inn and for Marriott, Roger Maxwell founded In Celebration of Golf in Scottsdale in the 1990s. The flagship store at the Seville at Scottsdale and Indian Bend Roads lives up to the company slogan, "The game's most celebrated golf shops." From golf art, to apparel, to books, to home decor, to kitchen and barware, to golf antiques, In Celebration of Golf stores carry everything a golf nut could ever possibly want to buy. Maxwell also started a course management division of the company and manages golf courses throughout the valley and state. (Author's collection.)

Crackerjax opened in the Scottsdale Airpark in the early 1990s, far from everything; now it is the center of activity. Its double-deck driving range has 66 tee stations with automatic ball delivery. Teaching pros give lessons and clinics. Children have their first golf experiences on the miniature golf course. Scottsdale families were pleased to have another place to play after the driving range and miniature golf course at Hayden Road and McDonald Drive closed. (Author's collection.)

Tim Bray, life member and former patron (president) of the civic group Scottsdale Charros, shows that even on the Charros' annual trail ride to remote parts of Arizona, golf is always possible. In 1991, Bray developed a way for golf courses in Scottsdale to use effluent water in lieu of groundwater so new golf communities could continue to develop in northern Scottsdale. He serves as project manager for two 13-mile-long pipelines, multiple pumping stations, and an underground water storage facility designed to deliver treated effluent water to irrigate more than 22 golf courses in northern Scottsdale. (Tim Bray.)

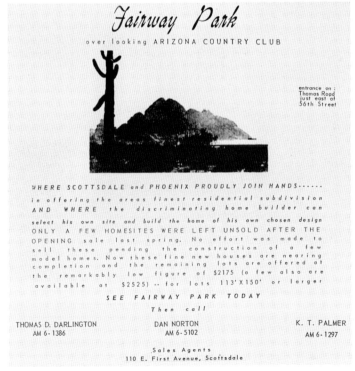

Fairway Park

over looking ARIZONA COUNTRY CLUB

entrance on :
Thomas Road
just east of
56th Street

WHERE SCOTTSDALE and PHOENIX PROUDLY JOIN HANDS------
in offering the areas finest residential subdivision
AND WHERE the discriminating home builder can
select his own site and build the home of his own chosen design
ONLY A FEW HOMESITES WERE LEFT UNSOLD AFTER THE
OPENING sale last spring. No effort was made to
sell these pending the construction of a few
model homes. Now these fine new houses are nearing
completion and the remaining lots are offered at
the remarkably low figure of $2175 (a few also are
available at $2525) -- for lots 113'X150' or larger

SEE FAIRWAY PARK TODAY

Then call

THOMAS D. DARLINGTON
AM 6-1386

DAN NORTON
AM 6-5102

K. T. PALMER
AM 6-1297

Sales Agents
110 E. First Avenue, Scottsdale

Developing residential properties around Scottsdale golf courses has been big business since the late 1940s, when Fairway Park was first envisioned around Arizona Country Club. Tom Darlington, Dan Norton, and K. T. Palmer were the sales agents. The three also served as brokers for lots surrounding Paradise Valley Country Club. (Mae Sue Talley, publisher, the *Arizonian*.)

Jerry Nelson is a top developer of golf course communities in Scottsdale. He began with the private Pinnacle Peak Country Club, the first 18-hole golf course north of Bell Road. He also developed the private 18-hole Troon Country Club, as well as Troon North, with its two 18-hole daily-fee courses. Nelson helped develop the Talking Stick Golf Course in the Salt River Pima-Maricopa Indian Community. He set new standards for environmentally sensitive design. (Scottsdale Historical Society.)

Lyle Anderson (right) and Jack Nicklaus (left) had never met when Anderson asked Nicklaus, the "Golden Bear," to design a championship course at the southern base of Pinnacle Peak in the early 1980s. The result was award-winning Desert Highlands, the first of many Jack Nicklaus Signature golf courses that the two have collaborated on in Scottsdale and the East Valley. Anderson went to great lengths to preserve the natural vegetation of the Sonoran Desert. (The Lyle Anderson Company.)

Although some say the FBR Open catches more people playing hooky from work than any other event during the year in Scottsdale, there is actually a lot of business transpiring in the corporate tents and skyboxes. Dozens of local and national corporations entertain clients, thank customers, and recognize outstanding employees at their FBR Open tents. Businesses benefit from tournament networking, and so do local charities, who receive proceeds from the tournament hosts, the Thunderbirds. (Author's collection.)

Everyone attending the FBR Open must pass through the huge tent that houses corporate exhibits of all kinds during tournament week. From putting contests, to live sports show broadcasts, to car and vacation giveaways, promotions are designed to target the demographics of the tournament gallery that are a marketer's dream. A record 539,000 attended the 2008 FBR Open, boosted by the presence of Super Bowl XLII in nearby Glendale. (Author's collection.)

Thirteen of the top 25 golf courses in Arizona as ranked by *Golf Digest* are in Scottsdale (the highest percentage of top-ranked golf courses of any city in the United States). The publication ranked Scottsdale as the number-one place in the Western United States for golfers to live in its June 2006 issue. Dozens of tour pros have called Scottsdale home when they could live anywhere. Many of the top golf course designers in the world are based in Scottsdale. With these great assets, Scottsdale is the place average duffers and scratch golfers alike make personal golf history every day. (Both Scottsdale Historical Society.)

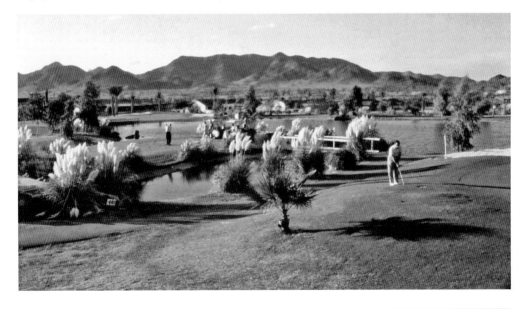

BIBLIOGRAPHY

Godfrey, William. *Papago Park: The Golf Course and Its History*. Philadelphia: Xlibris, 2007.

Hope, Bob, and Dwayne Netland. *Confessions of a Hooker: My Lifelong Love Affair With Golf*. Garden City, NY: Doubleday, 1985.

Huffman, Bill. *Arizona's Greatest Golf Courses*. Flagstaff, AZ: Northland, 2001.

Indian Bend Wash. City of Scottsdale Communications and Public Affairs Office, Scottsdale, AZ, 1985.

Klein, Bradley S. *Desert Forest Golf Club: the First Forty Years*. Scottsdale, AZ: Desert Forest Golf Club, 2004.

Peper, George, ed. *Golf in America: The First One Hundred Years*. New York: H. N. Abrams, Inc., 1988.

Smith, Jim. *The Bob Herberger Story*. Privately published, 1990.

Stuart, Richard M., ed. *The Phoenix Open: A 50 Year History*. Phoenix, AZ: The Thunderbirds, 1984.

The Silver Story: A History of Paradise Valley Country Club's First 25 Years. Scottsdale, AZ: Paradise Valley Country Club, 1978.

ACROSS AMERICA, PEOPLE ARE DISCOVERING SOMETHING WONDERFUL. THEIR HERITAGE.

Arcadia Publishing is the leading local history publisher in the United States. With more than 4,000 titles in print and hundreds of new titles released every year, Arcadia has extensive specialized experience chronicling the history of communities and celebrating America's hidden stories, bringing to life the people, places, and events from the past. To discover the history of other communities across the nation, please visit:

www.arcadiapublishing.com

Customized search tools allow you to find regional history books about the town where you grew up, the cities where your friends and family live, the town where your parents met, or even that retirement spot you've been dreaming about.